Tanner, Lesa.
Graton /
2009

37565008956798
heal

8.09

GRATON

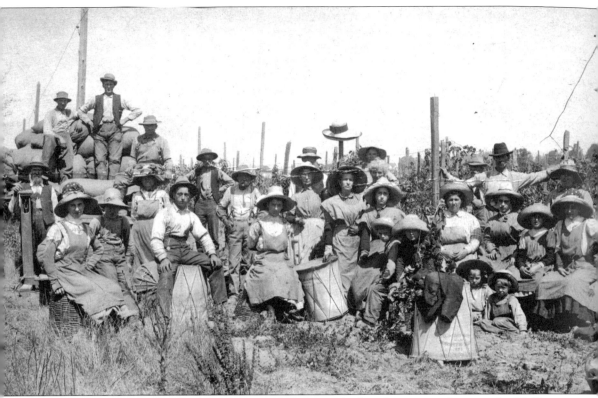

ON THE COVER: This photograph from 1910 shows the hop harvest workers on the Hallberg Ranch. It is from a postcard sent by John Hallberg to C. C. Donovan, a hop merchant in Santa Rosa, letting him know the harvest would be completed the following Wednesday. (Courtesy of Louise Hallberg.)

IMAGES
of America

GRATON

Lesa Tanner and the
Graton Community Club

ARCADIA
PUBLISHING

Published by Arcadia Publishing
Charleston SC, Chicago IL, Portsmouth NH, San Francisco CA

Printed in the United States of America

Library of Congress Control Number: 2008934520

For all general information contact Arcadia Publishing at:
Telephone 843-853-2070
Fax 843-853-0044
E-mail sales@arcadiapublishing.com
For customer service and orders:
Toll-Free 1-888-313-2665

Visit us on the Internet at www.arcadiapublishing.com

*I want to dedicate this book to the memory of my father, James
Dean "Jim" Tanner, who would have loved it so much.*

CONTENTS

Acknowledgments

I would like to thank the members of the Graton Community Club, who have managed to keep the club an active part of the Graton community since 1914. It is comforting to have its continuing traditions in this ever-changing world.

My thanks to all the current and former residents of Graton who shared their photographs and family histories with me. Much of Graton's history is not from books; it is straight from the photo albums and memories of those who lived it. However, I did have a written Graton history that was a valuable resource. Credit goes to Greg Dabel for sharing with me his 100 pages of manuscript about Graton's history. I appreciate his generosity. My deepest thanks to the people listed who allowed me to use their photographs and answered my many questions: Hazel Singmaster Jens, Louise Hallberg, Phyllis and Warren Welsh, Nick Pavoni, Shirley Baker Weeks, Merrilyn Joyce, Esther and Haven Best, Jim and Lucinda Winkler, Wanda and Buck Gardner, Chuck Lanier, Bud Chenoweth, Orrin Thiessen, Patsy Wong Yamamura, Bob Sturgeon, Sue Davis, Flora Clark and her daughters Christine Hincher and Shirley Hayes, Larry Tanner, Rosalee Carrillo, Frank Sternad, Guy Smith, Shirley and Lee Walker, Jean McNear Powers, Linda Stordahl and her son Eric Tate, Barbara and Art Paul, Kathy Sousa McCorkle, Kathleen Mayhew, Shirley Widdoes, and the West County Museum (an amazing resource for our community).

This book would also not be possible without the love and support of my mother, Judy Tanner, who loves her hometown of Graton as much as I do and helped me in numerous ways with the work on this book and every other aspect of my life as well. My great appreciation also for the things that keep me sane: Sebastopol Jazzercise, Thursdays at the Underwood, A's games with my beloved Auntie Barbara, and good food, movies, and conversation with all my lovely Graton ladies. Last, but not least, thank you Sebastian, Nick, and Gus, my wonderful sons, for being the best thing that ever happened to me.

INTRODUCTION

Graton sits in the middle of a beautiful valley bordered by Sebastopol on the south, Occidental on the west, Forestville to the north, and Santa Rosa to the east. It is historically known as the Green Valley area. The first inhabitants of what would eventually become Graton were the Pomo and Miwok Indians, most of whom died during a smallpox epidemic in 1837–1838. The land was under Spanish rule until 1824, when Mexico won its independence from Spain. Mexico acquired the large area it called Rancho El Molino, named after a mill built along the Atascadero Creek. In 1834, Capt. John Cooper was awarded the Rancho El Molino land grant. The mill was destroyed by flood in 1841, but the name remained until 1850 when California became a state. The rancho system was replaced by townships, and the Green Valley area became part of Analy township, along with Bloomfield, Freestone, Sebastopol, and Forestville. The name Analy was given by land surveyor and pioneer Jasper O'Farrell, who named the township after somewhere, or someone, in his home country of Ireland named Annaly. Pioneers began to discover the fertile land of the Green Valley. Early settlers included the Gregsons, Gilliams, and Sullivans, along with Clayton Winkler, John Walker, and the Ross family. They came from the east via wagon train, crossing the Sierra into the Sacramento Valley in search of a better life. When it was not found in the Gold Rush, they headed north to the abundant trees, temperate climate, and financial opportunities of the Green Valley. In the late 1800s, the farm land of the Analy Township would be nicknamed the "Gold Ridge" as settlers realized they could make more money in agriculture than in gold. For a time, the Green Valley portion of the Gold Ridge area was also known as Peachland because of the peaches planted from Occidental Road to Green Valley Road, but after a blight hit and prices dropped, the orchards were cut down and turned into charcoal, then replanted with apple trees.

In 1904, the Petaluma and Santa Rosa Railroad came to the Green Valley area. Santa Rosa realtor James Gray and banker James H. Brush saw the potential and bought the land surrounding the new train depot from Moses Hicks. They filed an application for the Green Valley Ranch subdivision, one of the first subdivisions in Sonoma County, and laid the streets out in a grid, naming them after themselves and their children. There was already a town named Green Valley in California, and at first, the town was referred to as New Town or Gray's Town. In 1905, the name was officially Graton. Families like the Robertsons, Wirts, and Hallbergs helped build the businesses needed in a new town. John Robertson was the first postmaster and a lumberyard owner, and the Hallbergs built the apple processing buildings downtown, including one of the first cold-storage facilities. Graton thrived in the first part of the century, despite enduring several major fires that burned most of downtown. The major source of employment was in agriculture, but a good living could also be made in logging, milling, and construction.

The town catered to working-class people, who were connected by their shared family ties, communal work experiences, and participation in community organizations. Churches were built, the Graton Community Club was founded, a volunteer fire department was formed, and several

schools served the growing population. A new wave of immigrants came in the 1930s from the Dust Bowl states looking for employment. Graton's population, at that time around 500 people, would swell into the thousands during harvest season as seasonal workers filled the many rental cabins and campgrounds located around Graton. The railroad ended passenger service in 1932, but the town was still growing. At mid-century, there were several grocery stores in town, a pharmacy and soda fountain, a shoe store, a barbershop, several bars and service stations, a few lunch counters, and many small businesses. The apple processing plants and canneries were going strong, their seasonally loud noise and noxious smell unnoticed by the locals.

The apple industry began to seriously wane in the 1970s, mostly as a result of increased competition. Dry-farmed Sonoma County apples could not compete with the well-irrigated, high-yielding, and cheaper crops from Washington state and the Central Valley. Businesses in Graton began to close as their customers moved on to find work. A sewer system was built in 1977 and new houses were constructed, but the campgrounds were sold to become Christmas tree farms and businesses, and virtually all the cabins were torn down. When workers from Mexico arrived hoping to find work, there was no more cheap housing available and they hung out on the streets and camped in the bushes along the creek. Graton began to be known more for the unemployed workers loitering downtown and its rowdy nightlife than its industry. By the early 1980s, the downtown apple processing buildings no longer operated but were occupied by Chateau St. Jean, Graton Beverages, A-1 Shower Door and Mirrors, Empire West Plastics, and Atelier One. The railroad no longer came through town, and the tracks were torn out. A park that was built with community support was abandoned. Apple orchards began to be removed and replanted with wine grapes. By the early 1990s, the town was derelict, and only locals knew what treasures remained.

In 1994, local builder Orrin Thiessen saw the potential, bought many of the downtown buildings, and began remodeling them, using old photographs of Graton as a guide. The old railroad route became the paved West County Trail, and new businesses came to occupy the revitalized downtown, including two Zagat-rated restaurants and an art gallery. The wine industry in Sonoma County began to grow, and Graton was recognized as part of the premiere Green Valley wine-growing region. Graton is home to many artists, writers, and musicians, as well as working-class families, professionals, and retirees. It is a diverse and active community, where the Graton Community Club still holds flower shows twice a year, the firefighters are volunteers, and Oak Grove School and the Pacific Christian Academy still educate local children. Graton was once known as the armpit of Sonoma County, but those who live there have always considered it the heart.

One

GREEN VALLEY PIONEERS

Col. Isaac W. Sullivan arrived in the Green Valley area with the Mitchell Gilliam party in 1850. He married Mary ("Polly") Gilliam in 1851, and together they raised 11 children. Their life story is told in *Patriarch of the Valley*, written by his granddaughter Emma Street-Hively in 1931 and published in 1977. This ambrotype photograph of him was probably taken shortly before he married. The list of pallbearers at Isaac Sullivan's funeral in 1891 was a roster of Green Valley pioneers: Lossen Ross, Calvin Davis, Winthrop Maddocks, Mitchell Ward, James Gregson, John McReynolds, James Ross, Henry Taylor, G. Hammey, Owen McChristian, Clayton Winkler, T. G. Wilton, Joseph Morris, John Wiley, Jesse Ross, and J. Chenoweth. They carried his coffin from his home to Gilliam cemetery in three shifts. (West County Museum.)

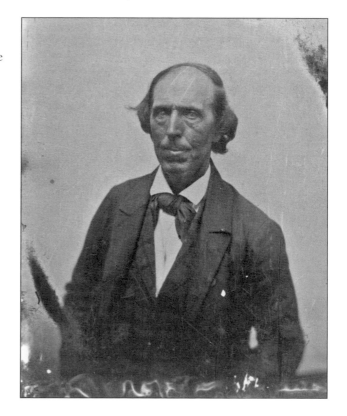

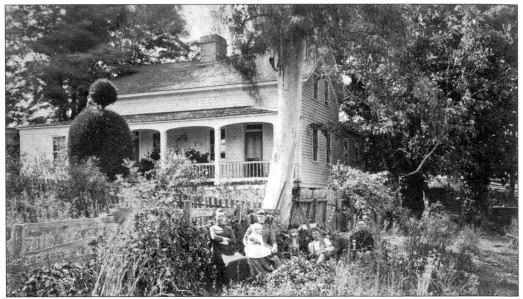

The Sullivans' first dwelling was a simple log cabin, but in 1859, this beautiful new home was built, with a sweeping view of the Green Valley and Mount St. Helena. This house still stands on Sullivan Road. Some of the Sullivan children are sitting in front. (West County Museum.)

The first barn on the Sullivan property was built in 1851 by log rolling with the help of neighbors. This photograph depicts how it looked around 1931. (West County Museum.)

Cornelius Gilliam was the son of Mitchell Gilliam and Polly Sullivan's brother. He was named after his uncle, Col. Cornelius Gilliam, who led emigrant parties to Oregon in 1844 and 1845 and for whom Gilliam County in Oregon is named. He is pictured in this tintype photograph with America Gilliam (standing) and Levira Frost. (West County Museum.)

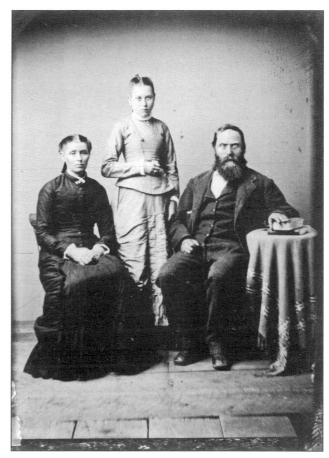

These happy women are four of Isaac and Polly Sullivan's five daughters around 1915. From left to right are Sophronia, born 1861, who married James Street; Amanda, born 1870, who married R. Gaillard; Letha, born 1865, who married William Coyan; and Minerva, born 1857, who married Charles Newell. (West County Museum.)

Nancy Sullivan was born in 1859 and married Albert H. Crabtree. She is the grandmother of Harold Narron, who, with his cousin Beverly Street, published Isaac Sullivan's biography *Patriarch of the Valley*. (West County Museum.)

Gladys Crabtree was Nancy and Albert Crabtree's daughter. She married Jesse Narron and lived in Graton with her sons Arthur, Harold, and Henry. After Jesse's death, she married Charles Berry. (West County Museum.)

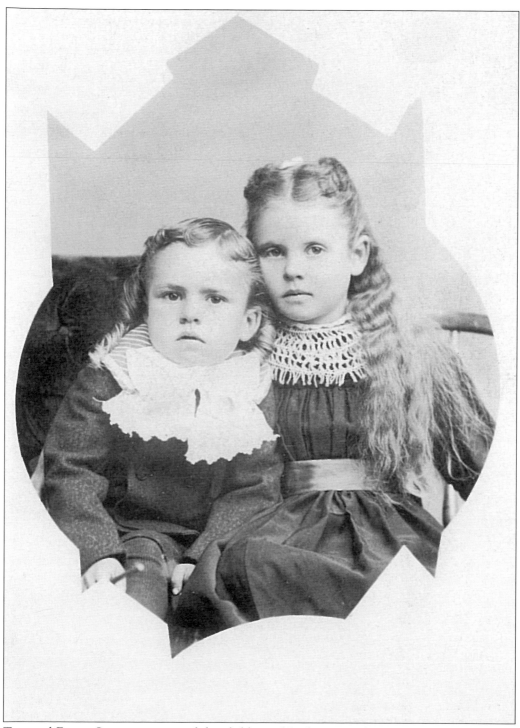

Tom and Emma Street were two of the children of Sophronia and James Street. Emma wrote the Sullivan family history using her grandfather's diaries and the memories of her mother, her uncle Cornelius, James Sullivan (Isaac's nephew), and Linda Butler, daughter of James and Eliza Gregson. (West County Museum.)

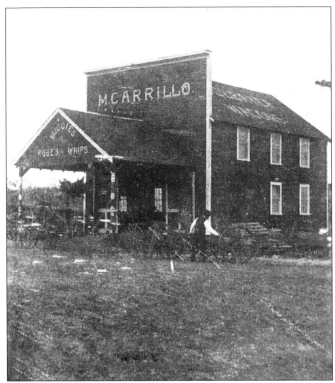

This image is from an advertisement for Manuel Carrillo's blacksmith shop, where he also sold buggies and accessories. It was located on Vine Hill Road, where the hydroponics plant sits now, at what used to be James O'Connell's plant. Manuel and his wife, Elizabeth, had three sons, Lawrence, Eugene, and Earl. Manuel was one of the brothers of Joaquin Carrillo Jr. and the great-grandson of Maria Carrillo. His family history is chronicled in a 94-page handwritten book, *History and Memories—The Carrillo Family in Sonoma County.* The Carrillo family were the first European settlers in Sonoma County. Manuel drowned in the Russian River on the Fourth of July 1906. (Rosalee Carrillo.)

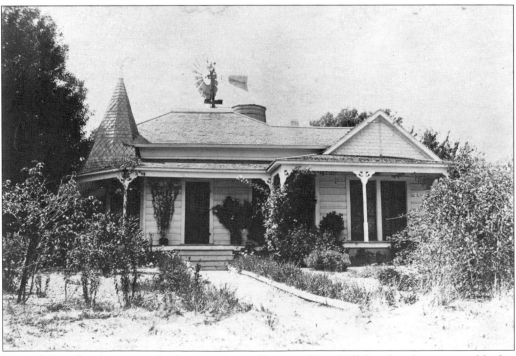

Manuel Carrillo's home was built in 1897. It still sits on Vine Hill Road and is occupied by his great-granddaughter Rosalee Carrillo, who sleeps in the same bed where her grandfather Earl Carrillo was born. (Rosalee Carrillo.)

Earl Leon Carrillo was born in 1903. He married Esther Hunter and had a son, Earl Leon Jr., in 1937. Earl Sr., his son, and his grandchildren—Gary, Laura, and Rosalee Carrillo—all attended Oak Grove School. (Rosalee Carrillo.)

Earl Carrillo attended the sesquicentennial of Oak Grove School in 2004 as the oldest living graduate. He died the following year at age 101. (Oak Grove School Association archives.)

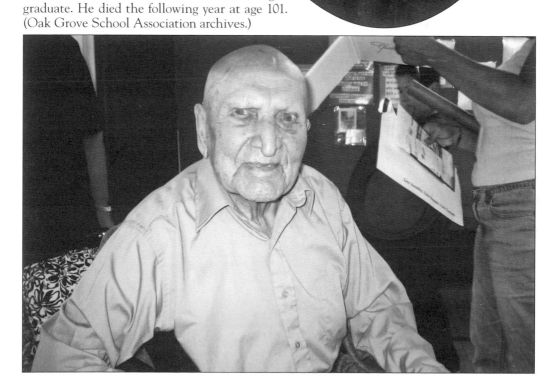

Tom Street (left) and Richard Gregson are standing on the porch of James Gregson's home around 1899. Richard was the grandson of James and Eliza Marshall Gregson. They built their home in 1853 to replace the log cabin they constructed after arriving in Green Valley in 1849. The Gregsons lived at Sutter's Fort before coming to Sonoma County, and their daughter Ann, born in 1846, was the first white child born in the Sacramento Valley. James Gregson worked with James Marshall prospecting for gold in 1948 but did not find his fortune there. The Gregson memoirs are archived at the Bancroft Library at UC Berkeley and are a valuable record of the lives of early pioneers. (West County Museum.)

In 1910, when this photograph was taken, James and Eliza's son John, the fifth of their 10 children, lived in this grand house that replaced the old homestead. He is seated in the middle on the porch. The house is now Spirit Hill Farm on Mill Station Road. (West County Museum.)

Ellen "Nelle" Gregson was born to John Gregson and his wife, Alma Hoyt, in 1891. Like her father, she was the fifth of 10 children. She married George Burns Cunningham of Sebastopol. (West County Museum.)

This photograph from around 1900 depicts several pioneer daughters and granddaughters. From left to right, they are Fanny Doty, Minerva Sullivan Newell, Henrietta "Rita" Pierini (daughter of Rebecca Gilliam and Valentine "Patrick" Pierini), Mary Ellen Gregson McChristian (wife of Sylvester McChristian), and Maude Newell, Minerva's daughter. (West County Museum.)

Owen McChristian was the son of Patrick McChristian, who was part of the Bear Flag revolt in Sonoma in 1846, as were his brothers Patrick Jr. and James. His brother Sylvester married Mary Ellen Gregson, and their sister Mary McChristian married Jasper O'Farrell. Owen's home was located on Mill Station Road, and pictured there in 1888 are (seated) Owen and Susan McChristian, who married in 1875; Cleo in her mother's lap; (standing) daughter Pearl; and (on horse) son Owen Alvin "Donnie." The man holding the horses came with the unnamed photographer. (Bob Sturgeon.)

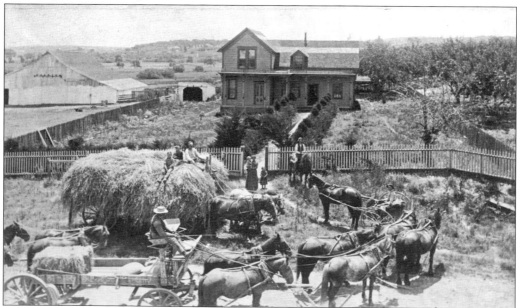

This photograph was taken by W. N. Collom, a San Francisco photographer, about 1893, at the remodeled McChristian home. Owen McChristian is sitting on the load of hay with Cecil and Pearl. Owen Alvin is sitting in the cart to the right. William McChristian (Owen Sr.'s brother) is on the horse. Susan McChristian is standing holding daughter Andra, and Cleo is beside her. The man in front is unidentified. (Bob Sturgeon.)

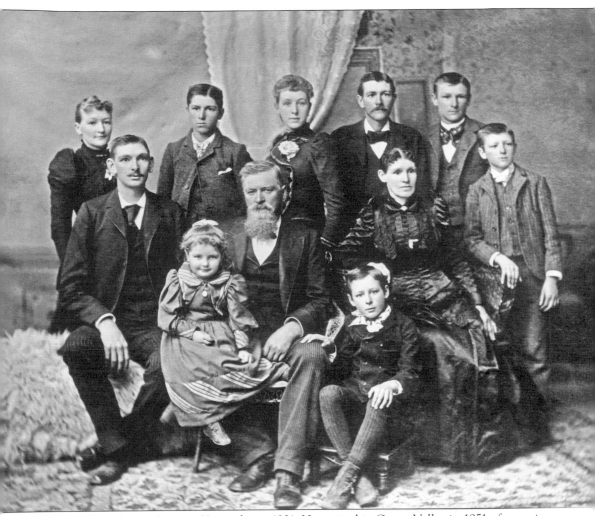

Clayton Winkler was born in Kentucky in 1831. He arrived in Green Valley in 1951 after trying his luck in the gold mines. He purchased 280 acres from the Lancaster Clyman family for $957. In 1860, he built a three-room log cabin that he shared with pioneer Miles Chenoweth. Clayton married Martha Brain in 1866 and built a home for them on the ranch where he farmed apples, hops, peaches, pears, prunes, and grapes. In this 1892 family portrait are, from left to right, (first row) Florence and Walter; (second row) George, Clayton, Martha, and Ernest; (third row) Sarah Jane ("Jennie"), Ed, Hattie, Arthur, and Oliver. (Jim Winkler.)

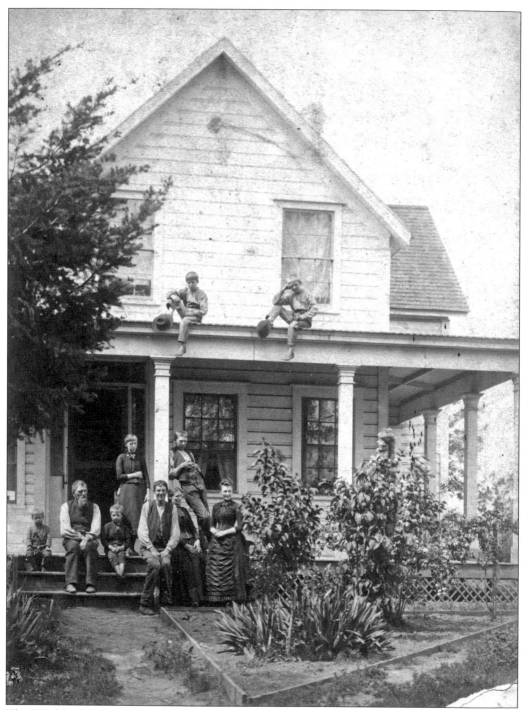

The Winkler family gathered at their home on the Winkler Ranch in 1886. Shown are (seated) Walter, Clayton, Ernest, Arthur, and Martha; (standing) Hattie, George, and Jennie; (on the roof) Edward and Oliver. Reportedly, when it was time to take the picture, Martha could not find her mischievous middle sons and told the photographer to go ahead and take the picture without them, unaware that they were on the roof. (Jim Winkler.)

Walter Winkler married Maria Antonia Feliz in 1906. The Feliz family came on the deAnza expedition in 1776 and helped build the Presidio in San Francisco. Ferdinando Feliz was given the Novato land grant but traded it for one in Hopland. Walter and Bea, as Maria was known, met while picking hops. They had two children: Gertrude, born in 1910, and Wallace, born in 1920. They lived in the house Clayton Winkler built until about 1922, when Walter tore it down and built the house that still sits on the Winkler ranch. (Jim Winkler.)

Clayton Winkler died in 1901, three years after he was knocked unconscious for several days by a bull while repairing a fence on the ranch. He never really recovered from the injury. Martha died in 1905, and they are buried together at Pleasant Hill Cemetery on Bodega Highway in Sebastopol. This photograph of the Winkler family plot was probably taken not long after Martha died. (Jim Winkler.)

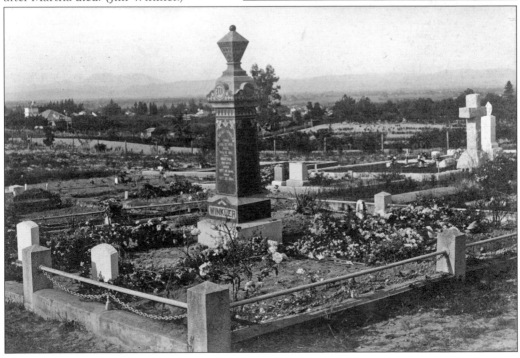

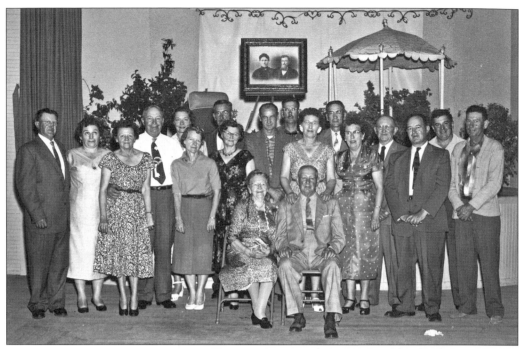

About 150 Winkler family members and guests gathered at the Graton Community Club in 1967 for Sarah Jane ("Jennie") Winkler's 90th birthday. Her brother Walter is sitting next to her. On the stage behind them is a portrait of their parents, Clayton and Martha. Jennie married George Sumner Williams in 1893, and they had nine children together. She died in 1968 when she was 101. (Jim Winkler.)

This photograph from 1949 is of Walter Winkler and his son Wallace ("Wally"). The remaining 33 or so acres of the Winkler Ranch now belong to Wally's son Jim. Clayton Winkler, Jim's son, was the fourth generation of Winklers to attend Oak Grove School, along with his sister Kristy. The Winkler Ranch is now planted with wine grapes. (Jim Winkler.)

George Denny Wirts was born in Ohio in 1854. His mother was from Wales. He came to California as a young man and met Margaret A. Middleton, who was born in Almador County in 1858. They married in 1879. When they first came to the Green Valley, they rented the Bowers Ranch, across from Oak Grove School. When it sold to Swedish immigrants Charles and Ann Gustafson in 1906, they built their home and farm on Sonoma Avenue. (Linda Stordahl.)

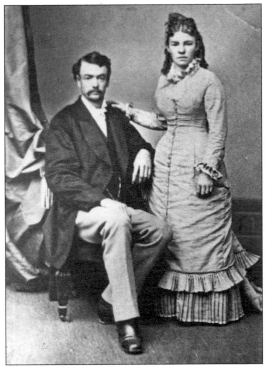

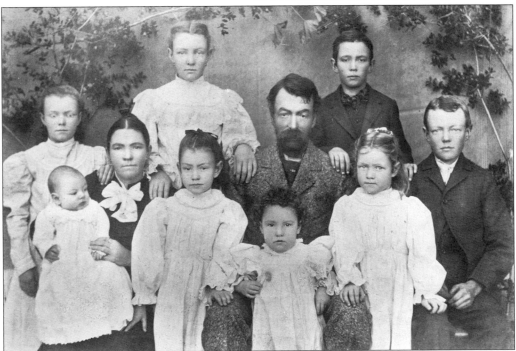

The Wirts family sat for their portrait in 1896. Pictured are (first row) baby George Bruce (who died later that year), Mary Alice, Alazuma, and Gertrude Della; (second row) Margaret, George, and Henry Edwin; (third row) Elizabeth Berniece, Sarah Frances, and Thomas Franklin. (Louise Hallberg.)

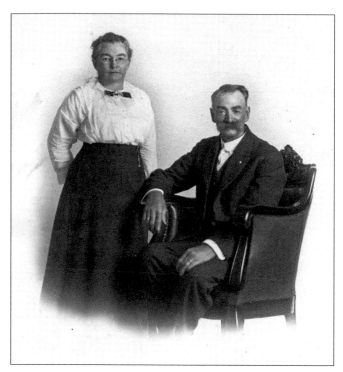

In 1914, when this picture was taken, George and Margaret had been married for 35 years. They had seen many of their children married to other local families. Della married Alfred Hallberg, a prominent apple rancher; Berniece married George McAuley, owner of the blacksmith shop in Graton; Alazuma married Jacob Errol Singmaster, builder of the first commercial dryer in Graton; and Alice married Walter Neep, son of Alfred Neep, who constructed the first house in the new town of Graton. (Linda Stordahl.)

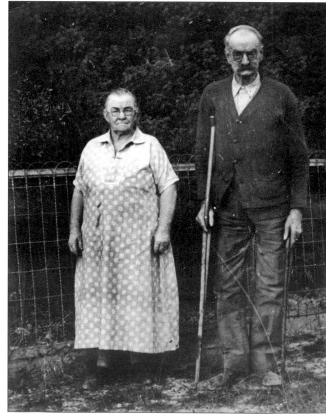

George Wirts died in 1934, and Margaret died in 1943. They are both buried in Gilliam cemetery, along with George's mother Mary and some of their children. This last picture of them together was taken around 1933. (Linda Stordahl.)

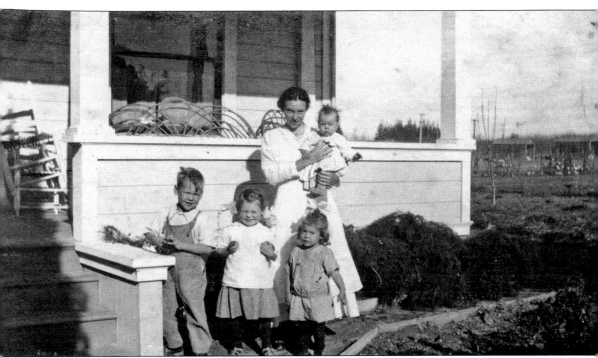

Alice Wirts Neep is standing by the front porch of her parent's home with her children in 1916. She is holding Elsie, who died of tetanus as a toddler after falling on a rusty file. In front of her are, from left to right, Bob, Doris, and Ida. The chairs visible over the rail of the porch are a beautiful example of bent willow furniture, and the others are probably chairs from the Faudre chair factory in Forestville. (Louise Hallberg.)

George and Margaret Wirts' daughter Alazuma is standing in front of her parents' house in 1942. Alazuma, who was nicknamed "Zonie," was a founding member of the Graton Community Club. (Linda Stordahl.)

This beautiful baby playing with her doll is Hazel Singmaster (Baker/Garrison/Hayes) Jens, one of Alazuma Singmaster's daughters. It was taken the year she was born, 1918. She is still an active member of the Graton Community Club, which her mother helped found in 1914. (Louise Hallberg.)

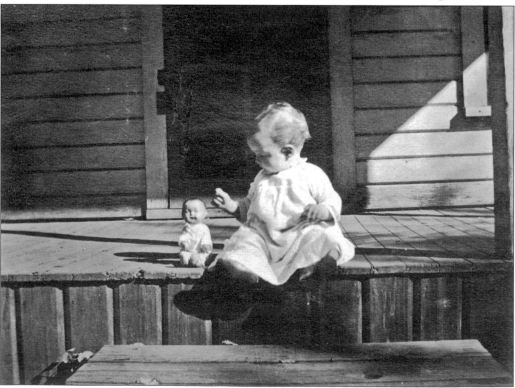

John Francis Hallberg came to the Green Valley area from Sweden in 1883. He married Louisa Neta Pearson in 1885 at the Hicks house and established his ranch on Oak Grove Avenue, near Oak Grove School. He grew hops, apples, cherries, hay, and more. This picture shows John and Louisa at their home, surrounded by hop vines, around 1904. From left to right are Alfred, Oscar, their cousin Elsie Green (holding the parasol), Ida, Louisa, and John. (Louise Hallberg.)

Alfred Hallberg was about five years old when this posed portrait was taken of him in 1891. Alfred and his brother Oscar would grow up to be prominent men in the Green Valley area apple industry, not only as growers but as owners and builders of dryers, canneries, and a cold-storage plant. (Louise Hallberg.)

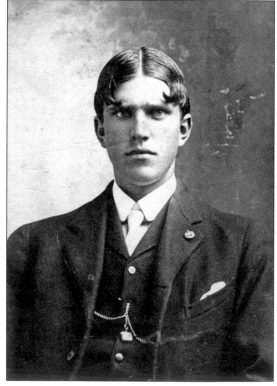

Alfred married Della Wirts in 1911 in a double ceremony with her sister Alazuma and Errol Singmaster. They were married at the home of William Rogers, the minister of the Green Valley Congregational Church. The home was a two-story house located at the corner of Peachland Avenue and Gravenstein Highway. It was torn down in 1968 when the Hallbergs built a large apple packing building on the site. They also had a fruit stand there for many years. This is Alfred's high school graduation portrait from 1904. (Louise Hallberg.)

This is Oscar Hallberg's high school graduation portrait from 1911. Oscar married Elizabeth "Bess" Barlow, a member of another prominent apple family. In 1919, after Prohibition began, he bought T. L. Orr's winery in Graton and converted it to an apple dryer. Later he built the first cold-storage facility in the county, helping create the market for fresh fruit and vegetables as well as processed. (Louise Hallberg.)

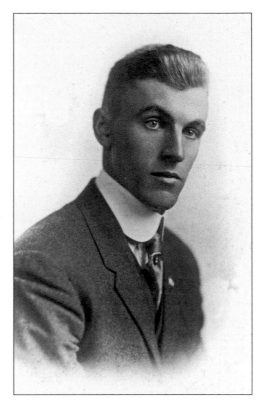

Ida Hallberg was born between her brothers Alfred and Oscar in 1891. This is her high school portrait from about 1909. She married John Rued, a member of another Sonoma County pioneer family. (Louise Hallberg.)

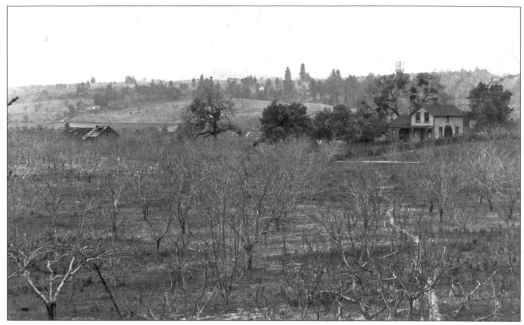

This view of the Hallberg home and ranch in 1904 is from Oak Grove Avenue looking southwest. The house is no longer visible from the road but still sits back in a grove of trees, occupied now by John Hallberg's great-grandson. Many of the apple trees are gone, replaced by wine grapes. (Louise Hallberg.)

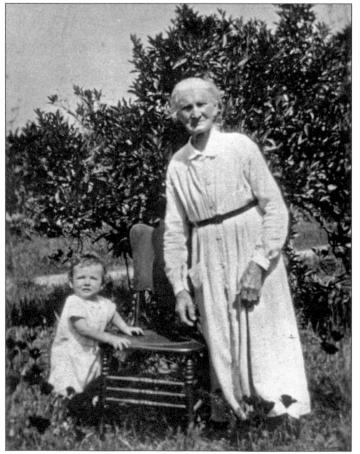

Louisa Neta Hallberg is standing with her grandson Harrison Rued on the Hallberg Ranch in 1929. Harrison Rued grew up to be a lifelong rancher and aviation history buff. He was cofounder of the Redwood Empire Aviation Historical Society in 1988, as well as the Pacific Coast Air Museum. He died in April 2007. (Linda Stordahl.)

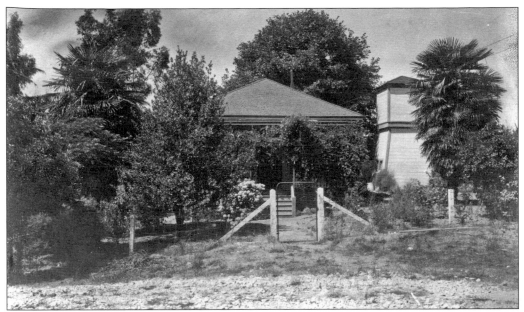

Alfred Hallberg built this home on the Hallberg Ranch in 1911. He and Della raised three children here, Louise, Esther, and Donald. Louise Hallberg still lives here, and it is now the site of Hallberg Butterfly Gardens. In the 1920s, Della planted a California native vine she found growing in a ditch and found it attracted Pipevine swallowtails. The plant was Dutchman's Pipe, and it still grows at the garden, along with many other plants cultivated to create a butterfly habitat. The Hallberg Butterfly Gardens became a nonprofit organization in 1997 and are open to visitors by appointment. Louise also records the weather every day, at the official U.S. Department of Commerce Weather Station for Graton established by her father in 1930. This picture was taken in 1919. (Louise Hallberg.)

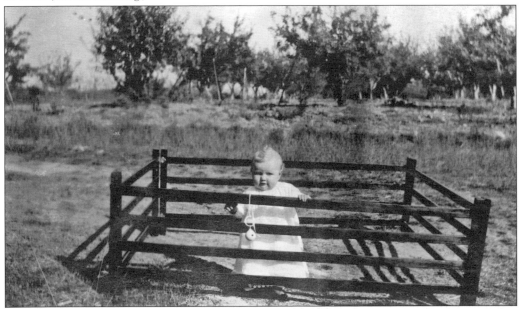

This is how babies were contained in the old days. In this photograph from 1917, Louise Hallberg is standing in her wooden "playpen" on the family ranch. (Louise Hallberg.)

Donna and Jessie Gamsby were sisters from Huntingville in Quebec, Canada. Jessie married John Anthony Robertson, whose father was a rancher in Valley Ford. Donna married Ralph Janes, the brother of T. J. Janes, proprietor of Graton's first grocery store. Donna was the first woman in Sonoma County to get her driver's license. Jessie met John while visiting her uncle Hollis Hitchcock (a founder of Exchange Bank) in Valley Ford. John wrote to her after she returned to Canada, but Jessie wasn't much interested. He went to try his luck in the Alaskan gold rush and, on his way home to Sonoma County, stopped to woo her. They married in Canada in 1901, lived in Washington state for a while, then came back to be part of the new town of Graton. (Phyllis Welsh.)

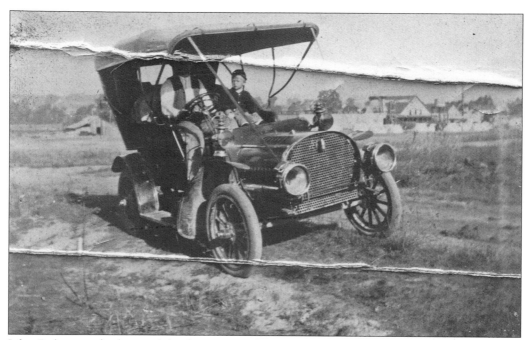

John Robertson had one of the first cars in Sonoma County, a 1905 Nash Rambler. Here he is in 1907, taking his two-year-old son John "Jack" Gamsby Robertson for a ride in a field near downtown Graton. One can barely make out the apple dryer, packinghouse, and cannery buildings on the right. (Phyllis Welsh.)

Jessie and John Robertson celebrated their 50th wedding anniversary at the Graton Community Club in 1951. Jessie was a founding member of the club and a past president. Her daughter-in-law Alice Robertson and granddaughter Phyllis Welsh also served as presidents of the club. John Robertson built the second commercial building in Graton, as well as a lumberyard, which he ran with his father and son. (Phyllis Welsh.)

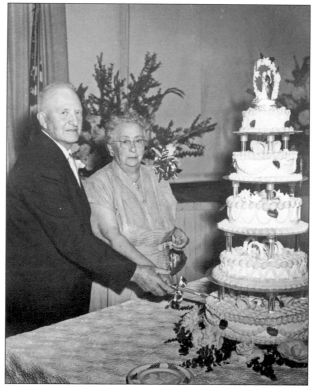

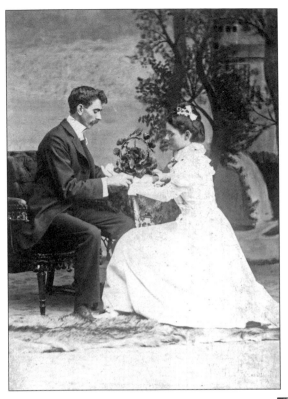

Arthur Franklin Ross, son of William Thomas "Tommy" Ross and Sarepta Ann Ross (whose mother was Lewhettie Gilliam), married Lillian May Waterbury in 1898. This is their wedding portrait. They had one child, a daughter, Alice, in 1906. Lillian Ross died, and Alice, age nine, came to the Green Valley area to live with her Ross grandparents. Sarepta was done raising children, so after a year, Alice went to live with her cousin Daisy van Keppel, daughter of Alice Ross Kimes, in Forestville. (Phyllis Welsh.)

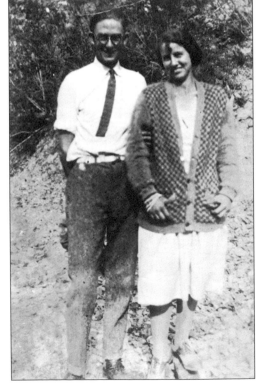

Alice Ross met Jack Gamsby Robertson, son of John and Jessie, at Analy High School. This picture was taken in 1924, two years before they married. Alice Robertson wrote the Graton column for the *Sebastopol Times* from 1939 to 1983. (Phyllis Welsh.)

Two

A Town Called Graton

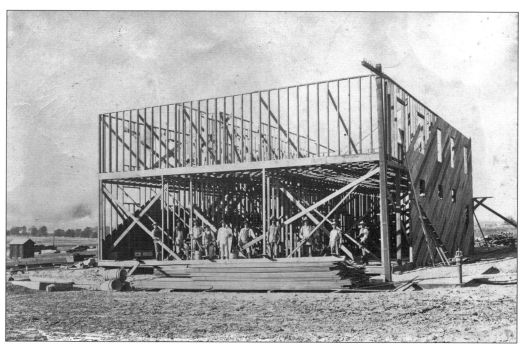

James Gray and J. H. Brush laid out the streets of their Green Valley subdivision (one of the first in Sonoma County) and named them after themselves and their children. The area had been called Green Valley for over 50 years, but there was already a town in California with that name, so at first, the town was simply referred to as "New Town" or "Gray's Town." In 1905, it became Graton. The first commercial building in Graton was the Union Block building, seen here under construction. It was located on the northeast corner of Edison Street and Main Street (Graton Road). One of the men in the picture is Ed Wirts, son of George and Martha. The Union Block had businesses downstairs and rooms for rent upstairs. (Hazel Singmaster Jens.)

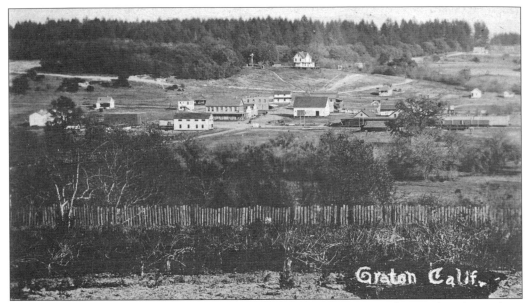

One of the earliest views of Graton, the picture on this 1906 postcard was taken from where Dyer Avenue is now. The Hicks house, by then James Gray's home, is clearly visible on the hill above the town. The large white building on the left of the dirt road is the incubator factory that would eventually move into town and become the Graton Community Club. The dryers are on the right, and a Northwestern Pacific train can be seen heading north on the railroad tracks by them. (Graton Community Club.)

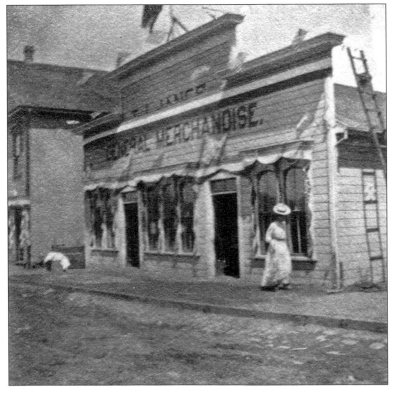

T. J. "Jeff" Janes was the proprietor of the first store in Graton, which was built by John Robertson. The store would have just opened when this 1905 photograph was taken. The hotel is on the left. (Phyllis Welsh.)

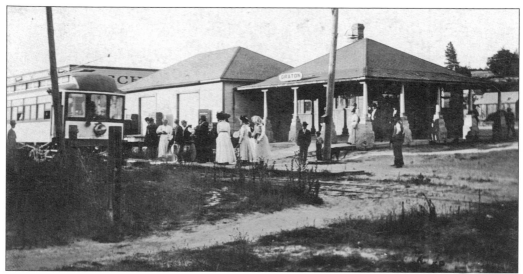

Graton was founded to take advantage of the Petaluma and Santa Rosa (P&SR) electric train coming to the area in 1904. The depot was located where the Graton Fire Department is now. This postcard image is from 1909. A fountain was built across from the depot on the south side of Main Street. Unfortunately there was not enough water pressure for it to run continuously, so it flowed in spurts, prompting the nickname "Squirtsville" for Graton. After passenger service ended in 1932, the fountain was filled in and used as a planter. It was finally removed in the 1960s. (Phyllis Welsh.)

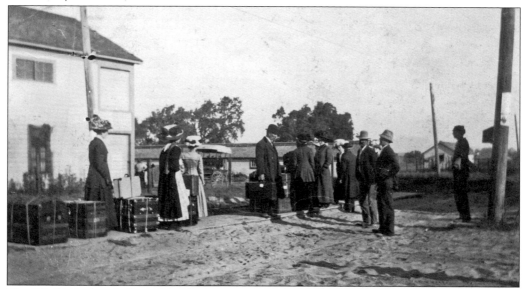

The P&SR Railroad allowed residents easier access to jobs in other areas when the harvest in Graton was over. In 1910, almost everyone waiting here on the west side of the tracks was heading to Santa Cruz to pack apples for Mitchell and Goodall of San Francisco. They would take the train to Petaluma, catch the paddle-wheeler *Steamer Gold* to San Francisco, then the Southern Pacific train over the mountains to Santa Cruz. The building to the left is the Incubator Building. In this picture, from left to right, are Lela Reynolds, Margaret Gilliam, Victoria Barnes, Jeff Janes (the boss), Della Wirts, Alazuma Wirts, Edith McAnnich, George Wirts, Bertraim Bowers (the only one not going to Santa Cruz), and George McAuley. (Hazel Singmaster Jens.)

T. S. Houger and George McAuley founded their blacksmith shop in 1906 at the site of what is now the Graton Post Office. The Houger home, visible behind the shop, still sits at the corner of Edison and Irving Streets. The shop closed around 1916, as cars came into vogue. (Hazel Singmaster Jens.)

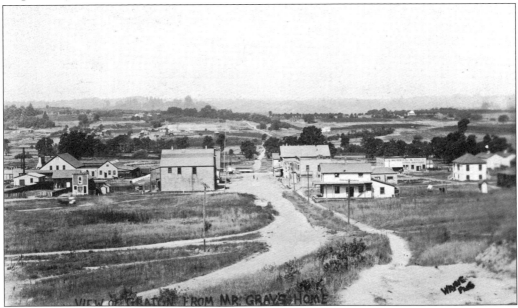

This postcard view of Graton in 1909 was taken from above town looking west. Many of the postcard images of Graton were taken by Joseph C. Wayne, a photographer from Petaluma. In 1916, he sold his studio to Dr. S. S. Baldwin of New York. Because of the many fires Graton endured, none of the visible buildings in this photograph still exist. (Hazel Singmaster Jens.)

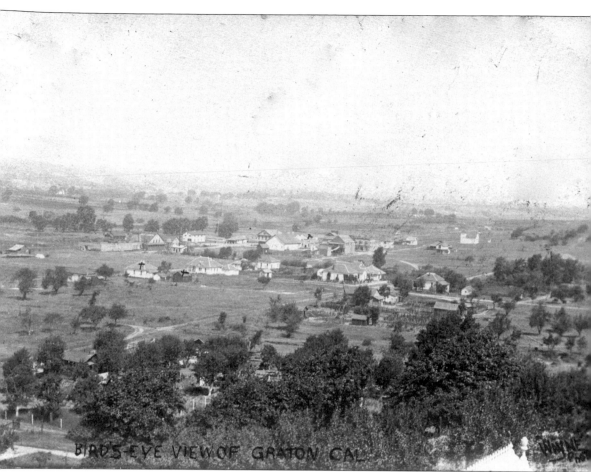

BIRDS-EYE VIEW OF GRATON CAL

Jessie Robertson sent this postcard picture, taken looking northwest from the Bowers Ranch near Oak Grove School, to her sister in 1909. She made little marks on it in pen to show her house at the corner of Edison and Donald Streets, the "auto house" behind it, and the store John Robertson built downtown. Running right to left is Donald Street, and the cross street is Brush Street. Many of the houses in this photograph are still standing, including the first house built in Graton. That house, at the northeast corner of Brush and Donald Streets, was actually moved there from Bennett Valley in Santa Rosa. Santa Rosa was split into north and south sides by Santa Rosa Creek. The north side had more money and people, and it was decided to locate the courthouse there. Soon families and merchants from the south side relocated to the north, abandoning many buildings. Alfred Neep sawed one of the abandoned homes in half and hauled it with horses to Graton, where he put it back together again. (Graton Community Club.)

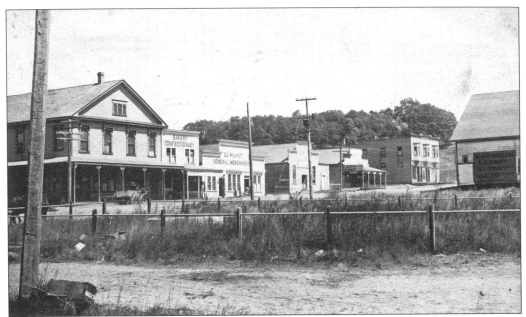

In 1912, when this photograph of the north side of Main Street was taken, E. L. Wilhoit was the proprietor of the general store. The building across the street is the livery stable, and the advertisement on it is for the local shoe store. It reads, "We have shoes for everybody. They fit both the pocketbook and the feet." (Hazel Singmaster Jens.)

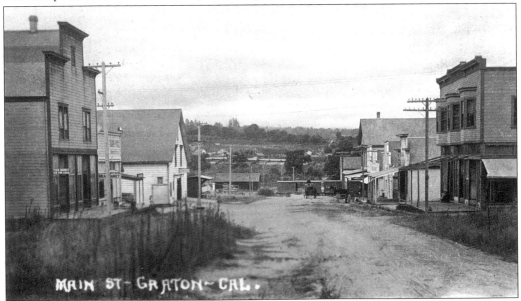

At the bottom of this 1913 photograph are some freight cars going through town on the railroad tracks. Originally, James Gray and J. H. Brush envisioned developing residences on both sides of the railroad track, but there was not enough interest, so Graton grew only above the tracks. The first building to the right is the Union Block building. The building to the left, known as both the Kimes building and the Hallberg building, housed, at various times, Sam Farris's butcher shop, a radio repair shop, a general store, and, for a while, the post office with Lewis Johnson as postmaster. There was also a barbershop on this side of the street. (West County Museum.)

Downtown Graton was surrounded by open space, with room for small family farms as well as large ranches. This undated photograph, probably from between 1905 and 1910, was taken from the hill above south Brush Street, looking west. The two large buildings to the right rear are T. L. Orr's winery, which operated until the 18th Amendment passed and Prohibition began. Before that time, wine grapes were an important part of Green Valley agriculture. In 1919, Oscar Hallberg bought the buildings and converted them to dryers. They later burned, and he replaced them with the red-brick building that now houses Atelier One. (West County Museum.)

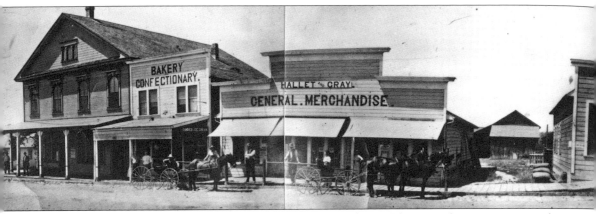

This panoramic image of downtown Graton was taken around 1914. The general store was managed at that time by Hallet and Gray, and Charles Hallet operated the store in the middle, which sold lumber from John Robertson's mill. On the far left was the hotel, and on the far right was the Union Block building. To attract tourists arriving on the P&SR Railroad, a park was created up the hill in a large grove of fir trees (eventually Handy's Grove), featuring a small zoo, a dance

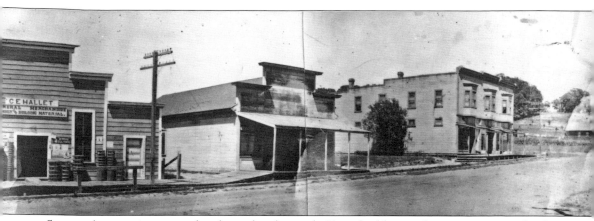

floor, and at one time a wooden shoot-the-chute ride. Every building in this picture, except for the Union Block on the far right, burned down in 1915. The Graton depot, which can be glimpsed on the far left, burned when another devastating fire years later burned everything on the northwest side of Ross Road, including an apple dryer, freight shed, feed store, and packinghouse. (Graton Community Club.)

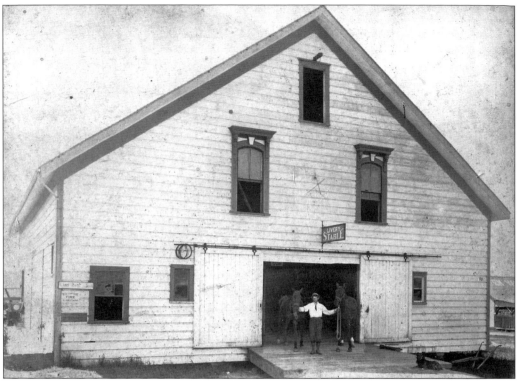

This photograph from 1911 shows the livery stable on the south side of Main Street that was owned and operated by Frank and Fred Neep. When cars began to replace buggies and wagons, the Neeps converted the livery stable into a automobile repair shop and gas station. In 1928, they sold it to the Sousas, who sold it to the Muellers in 1930. The Muellers removed the upper story and hay loft and rented cabins on the property. In 1942, Earl and Myrtle Baker bought it and added a breakfast and lunch counter. (Shirley Weeks.)

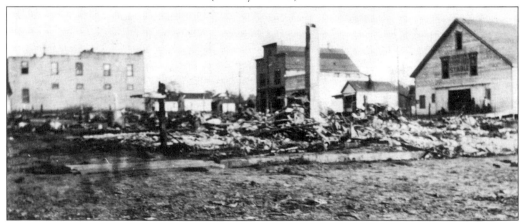

In 1915, fire swept through the north side of Graton's Main Street. The hotel's chimney was still standing. The only building that survived was the Union Block. After the rubble was cleared, it was moved down to the northeast corner and put on the foundation of the destroyed hotel, with its front facing west. It functioned as the town's hotel for many years, then sometime in the 1930s, perhaps after passenger service was discontinued by the Petaluma and Santa Rosa Railroad, it became a bar owned by Elmer Crowell, with rooms to rent upstairs. (Hazel Singmaster Jens.)

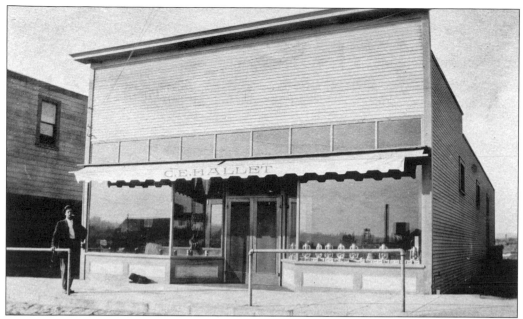

C. E. Hallet's Store was the first structure rebuilt after the Union Block was moved to the northeast corner. This picture was probably taken around 1916, and shows the store next to the Union Block building. The store would become Spooner's Grocery store and be expanded and remodeled. Heintz's hardware store would be built next door, and the Graton Post Office would move there in the 1930s. The post office was in C. E. Hallet's store at this time, then across the street in the Hallberg building. (Phyllis Welsh.)

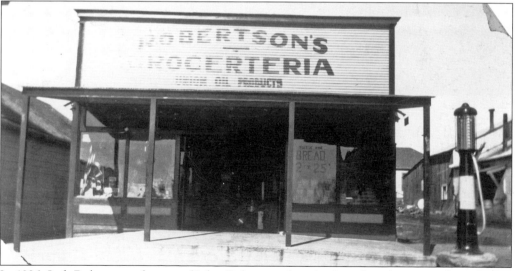

In 1926, Jack Robertson, the son of John Robertson, bought three lots downtown from Sophie Johnson, for $20 per lot, and built a grocery store. Robertson's Groceteria was next door to the Russian River Bakery, which sat on the corner previously occupied by the Union Block building. The bakery was owned by Dan Longbrake, who lived in the house behind it. Jack had just married Alice Ross, and they used the $300 left over after their Tijuana honeymoon to stock their store with "twelve cans of everything." They also had one of the first gas pumps in Graton. (Phyllis Welsh.)

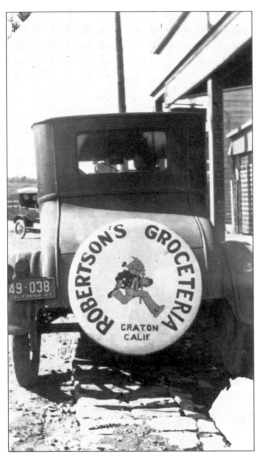

Jack Robertson drove his Ford truck to Santa Rosa Grocery company every evening to replenish whatever sold that day. In 1928, the Russian River Bakery next door burned. A young man who lived nearby helped empty the valuables out of Robertson's Groceteria when it looked like it might burn too. He grabbed the huge metal cash register, carried it across the street, and set it on the porch of the butcher shop. When the fire was out, he went to carry it back—and could not lift it! It took two men to carry it back to the store. The bakery was never rebuilt. (Phyllis Welsh.)

The Wong and Dunn families started Paul's Market after Jack sold the building and moved up the hill to run a business at Handy's Grove. This picture shows the market in 1936. It was a full-service grocery store with fresh fruit and vegetables and a butcher shop. (Patsy Wong Yamamura.)

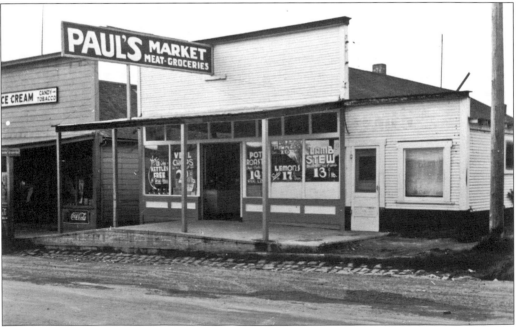

The Wong and Dunn families are gathered in front of the market in 1936. Patsy Wong is standing in front with Mark Dunn squatting down next to her. Behind them, from left to right, James and Pearl Wong are standing with Alice and Paul Dunn and an unidentified visiting friend. (Patsy Wong Yamamura.)

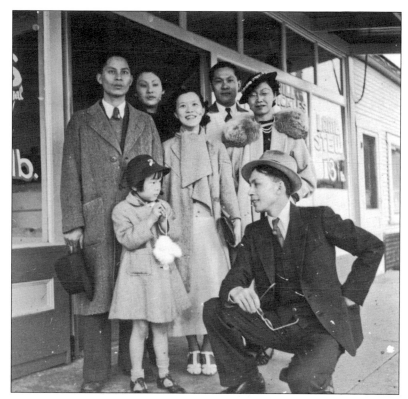

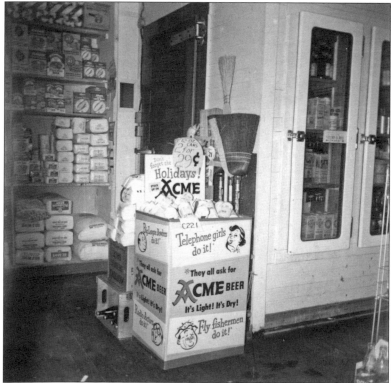

This photograph shows the interior of Paul's Market in 1936. To the right are the refrigerated cases, and to the left are shelves of flour, cornmeal, and baking mixes. Note the price of Acme beer—two cans for only 29¢. (Patsy Wong Yamamura.)

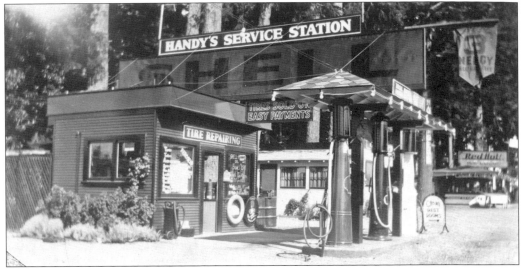

Jack Robertson sold his business downtown and went up to Handy's Grove, also known as Handy's Corner, to run this gas station, repair shop, campground, and cabin rental. This picture was taken in 1932. The former site of the Graton Park, it was named Handy's after it was purchased by Roy and Henrietta Handy. Roy lived with the Wirts family while working on the construction of Gravenstein Highway and liked Graton so much he decided to buy the park land and stay. He kept the zoo going for awhile (Bob Neep took care of the animals) and developed the campground and service station with cabins at the northwest corner of Graton Road and Highway 116. (Phyllis Welsh.)

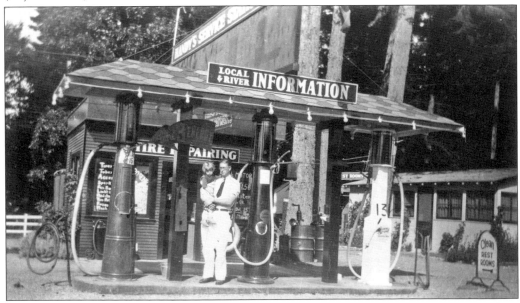

Jack Robertson is standing in front of Handy's Service Station holding his three-year-old daughter Phyllis. He would only run the station for a few years, then go on to build a sawmill on Meeker property behind Bohemian Grove with his father and to manufacture portable sawmills to be sold throughout California. After World War II, Jack bought 47 acres of land on Green Valley Road from his father (who had acquired the land in a trade from James Gray) and built and sold houses. In 1933, when this picture was taken, gas cost 15¢ per gallon. (Phyllis Welsh.)

John Robertson built his home in 1905 at the southeast corner of Edison and Donald Streets. John was the first postmaster in Graton and had many businesses around town, including a lumberyard, planing mill, and hay store. He also built Robertson's cabins on Brush Street, which provided temporary housing for many of Graton's seasonal workers for $5 a month. This photograph was taken in 1936. (Phyllis Welsh.)

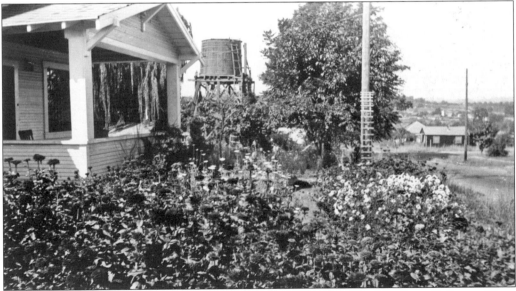

Jack and Alice Robertson built their home behind his parents' house on Donald Street. Their neighbors included the Charles Hallet family (northeast corner of Donald and Edison Streets) and the Singmaster family (northwest corner of Donald and Brush Streets). This picture from 1936 is from the front yard of their house looking west. They had their own water tower, as did many families. Downtown Graton got its water from the Graton Water Works maintained by John Robertson. The prominent water tower on Bowen Street was fed by the reservoir located up on Oak Grove Avenue, across from the back of the school. The water tank developed too many leaks to repair and was taken down in 1987. Its support structure still stands. (Phyllis Welsh.)

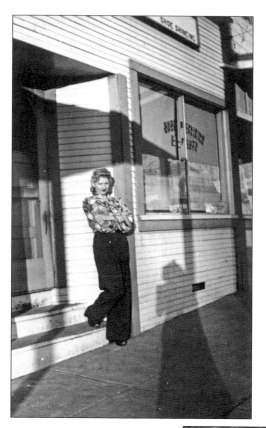

In 1942, this picture of Melba Flesher was taken in the doorway of the drugstore building downtown. Melba bought Upp's Pharmacy in the early 1930s and changed the name to Flesher's Fountain. The drugstore and fountain filled prescriptions and sold ice cream, sundries, and penny candy. Melba ran the business until 1959; then it was run by Harriet Jackson, then Nina Baker and Mary and Leonard Farmer, then Ruby and Erhardt Hanson, who bought the building in 1971. Erhardt also ran the Graton Hatchery on Dyer Avenue. At this time, Fouts Shoe Repair was also located in the building. (Phyllis Welsh.)

Pete Garrison owned Garrison's Motel and Garage on Ross Road. Garrison's Motel consisted of a series of connected cabins on each side of a court with a communal laundry room and bathrooms at the rear. It was located next to where the Graton Post Office is now. This 1953 photograph shows the children who lived in the cabins celebrating Larry Tanner's 11th birthday. Larry is standing behind the cake, and to the right of him is Carolyn Matthews; the other children are unidentified. Madge Ikenberry lived in the first cabin and watched the children while their parents were working. (Tanner family.)

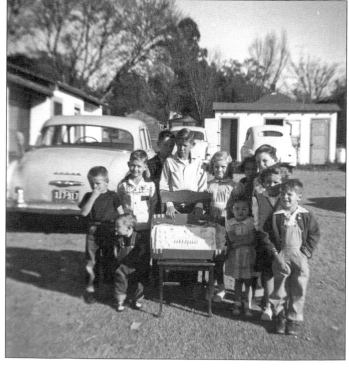

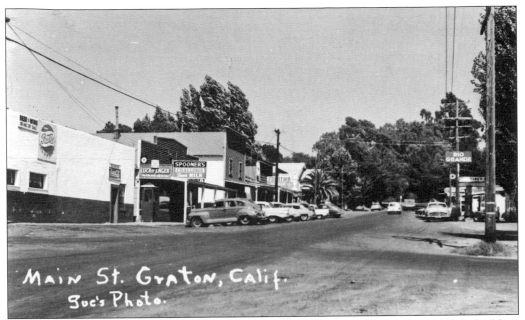

This view of downtown Graton looking east is from a 1959 postcard. The Union Block building on the left no longer has its upper story, lost its original windows, and was stuccoed, destined to live out the rest of its days as a bar. Baker's Lunch is pumping Rio Grande gasoline, and Spooner's has an enclosed phone booth in front of the store. Spooner's was sold to Milt Flesher, Melba's husband, in 1962. He had been working there since 1931. Milt sold it to George Husary in 1971. (Graton Community Club.)

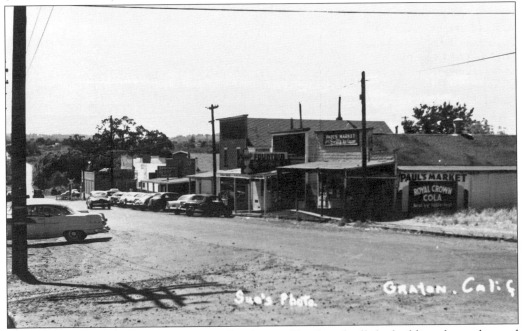

Looking west in 1959, Main Street has a familiar profile, though all the buildings have changed over the years. The post office was located in the building in the middle of the block, formerly Heintz Hardware Store. (Graton Community Club.)

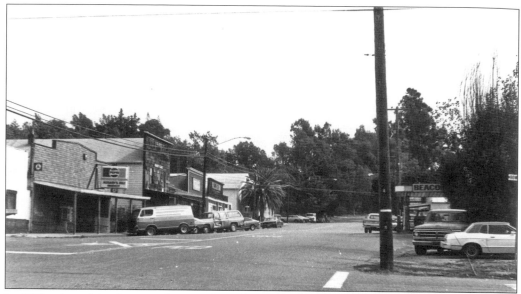

In 1979, when this photograph was taken, the apple industry was in a slump. O'Connell's and Hallberg's had closed downtown, and the wine industry was just getting started. Spooner's became Husary's Market in 1971, the post office was relocated, Flesher's Fountain was soon to be gone, and Paul's Market had been purchased by Annie Osborn. Skip's Bar and Grill was going strong, along with two other bars, Louie's Place and El Tenapa (formerly Babe's, at the southeast corner of Edison and Main Streets). Baker's was now selling Beacon gasoline, which Myrtle Baker would sell until she was forced to shut down her pumps by the Environmental Protection Agency in 1990. (West County Museum.)

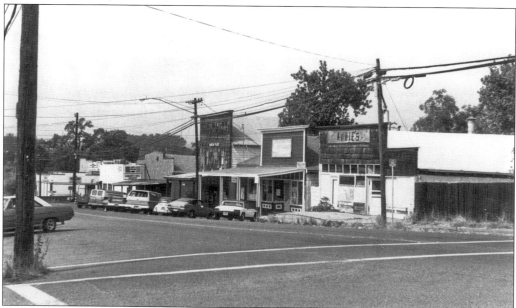

The Northwestern Pacific Railroad still went through Graton when this photograph was taken looking west in 1979, but not for much longer. By 1980, the trains were gone, and the tracks were removed later that decade. The right-of-way began to be acquired to create a trail along the train route, and in 1998, the paved West County Trail was officially opened. (West County Museum.)

Three

APPLES, HOPS, AND OTHER CROPS

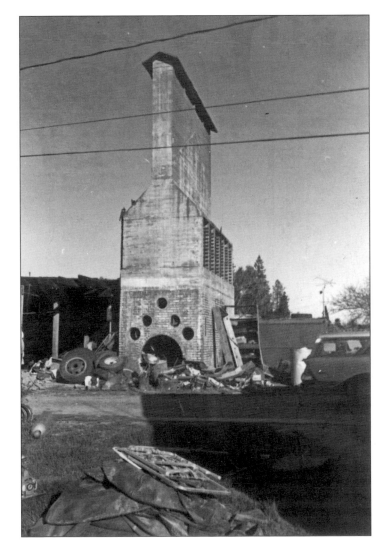

The first apple dryer in the Graton area was built in 1880 on the Bowers Ranch, located across the street from Oak Grove School. The ranch was bought in 1906 by the Gustafson family, who farmed on it for many years. When this photograph was taken in 1979, the rotting wooden structure around the brick dryer had been removed after many years of abandonment. It was finally completely torn down in 1997 when the property became the Saw Tae Win II Dhamma Center, a residential Buddhist facility. (West County Museum.)

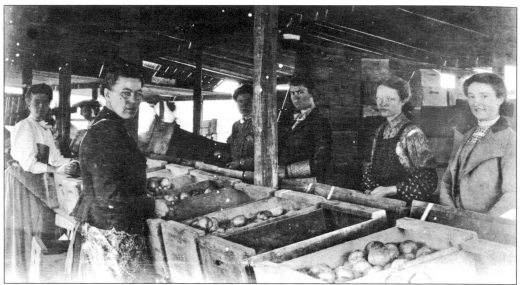

This photograph from 1906 shows a group of women sorting apples at T. J. "Jeff" Janes's packinghouse and dryer. The women on the right are members of the Wirts family. In the days before cold storage, dehydrating peeled and sliced apples was the only way to preserve and ship them. (Hazel Singmaster Jens.)

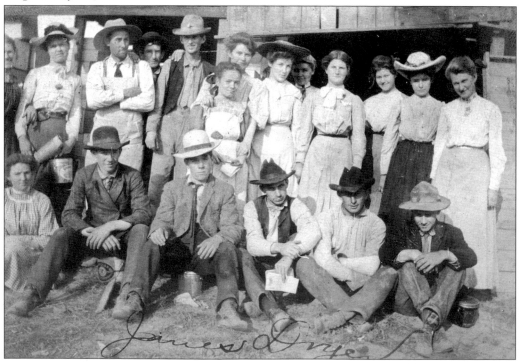

Janes's sorting and packing crew gathered for a photograph outside his dryer in 1907. Gravenstein apples were introduced to Sonoma County by William Hunt in 1869. Nathaniel Griffith was the first to successfully cultivate them, and by 1880, Gravensteins were grown throughout the West County. Though they do not ship well, Gravenstein apples are excellent for drying and for making juice and applesauce. (Hazel Singmaster Jens.)

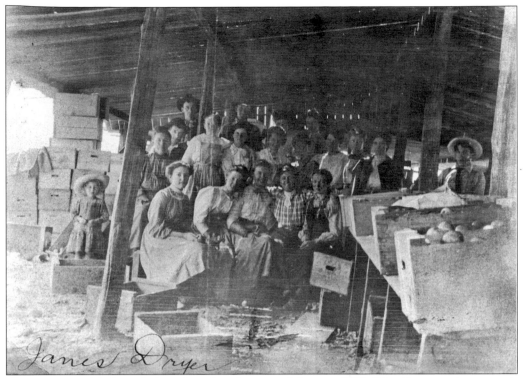

Janes Dryer

The crew assembled inside Janes's packinghouse and dryer in 1906. The Gravenstein season is early, so when it was over, crews could travel to another part of the state to work, then return to Graton for the late apples. (Hazel Singmaster Jens.)

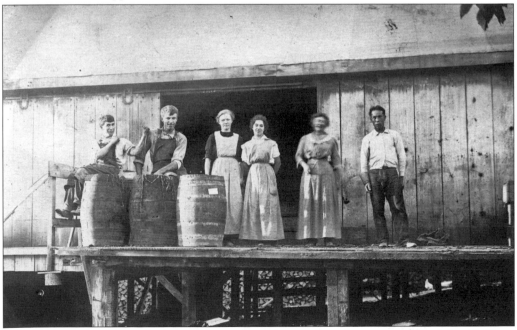

Della Wirts is third from the left in this picture of an apple packing crew at the John Hallberg Ranch, taken around 1907. This dryer burned down in 1908. (Louise Hallberg.)

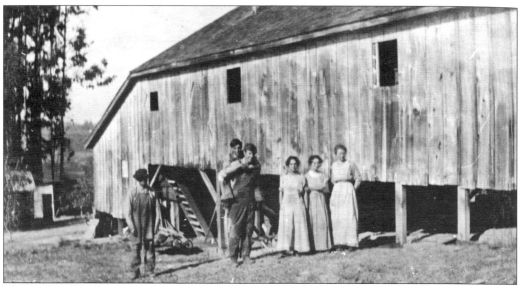

This photograph from 1915 shows the rebuilt dryer on the John Hallberg Ranch. Within a few years, Arthur and Oscar Hallberg would build dryers and processing plants in downtown Graton and discontinue using the ones on the ranch. (Louise Hallberg.)

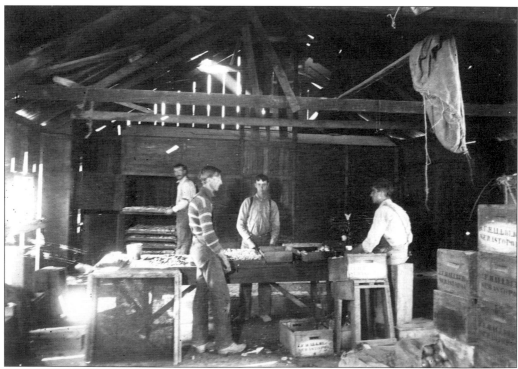

The interior of the Hallberg drying shed is shown this undated photograph. After peeling and trimming, the apple slices were laid on trays, then the trays were put into the sulfur box for a while, then removed and stacked into slots to dry, as the man in the rear of the photograph is doing. Sulfur fumes were an industrial hazard, and many workers' bronchial tubes were damaged working in dryers. (Louise Hallberg.)

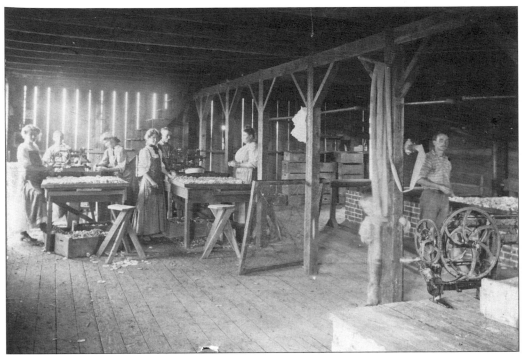

This apple dryer belonged to Andy Frei, one of the Frei brothers. The woman on the far left is Lena Heintz. The man operating the peeler on the right is Errol Singmaster. The photograph was taken in 1909. (Hazel Singmaster Jens.)

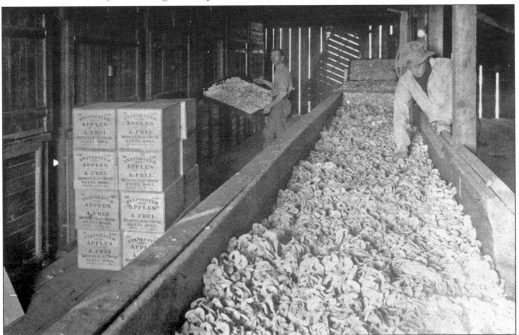

Walter and Andy Frei are working in their apple dryer in this 1909 photograph. The bin is full of dried apples waiting to be packed. A tray of apples is either being inserted or removed from drying racks on the left. (Bob Sturgeon.)

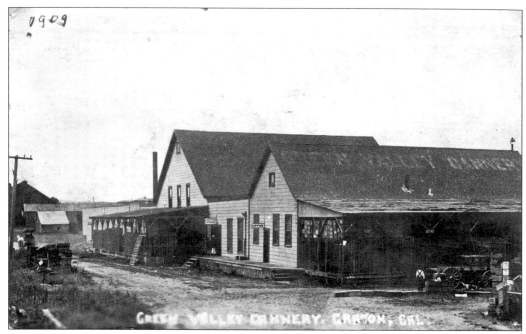

The Green Valley Cannery was located along the southwest side of the railroad tracks, as shown in this 1909 postcard. The season began with cherries, then progressed through peaches, pears, tomatoes, and string beans. (Hazel Singmaster Jens.)

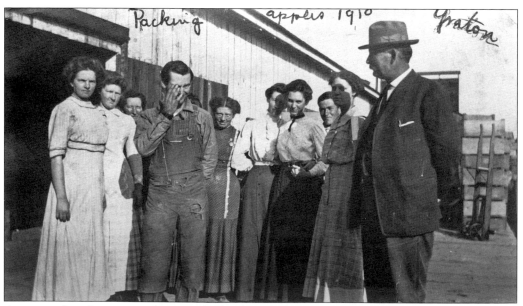

A group of workers is standing on the loading dock at Janes's dryer in this 1910 photograph. From left to right are Alzeda Madden, two unidentified, (in front) believed to be Lester Tallman, unidentified, Doris Sullivan, Elsie Flesher, Frankie and Phoebe Tallman, and the boss, T. J. Janes. (Hazel Singmaster Jens.)

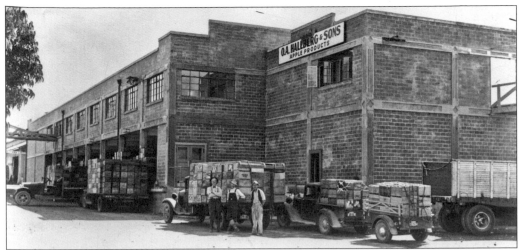

In 1943, Oscar Hallberg built a new dryer in Graton, on the site of the former T. L. Orr Winery building he had converted to a dryer in 1919. He ran it with his sons Donald and Robert. Wooden dryers burned down easily, and the new ones were made of brick, concrete, or metal. The conveyor belt on the left ferried boxes of apples from the loading area on the opposite side of the street. The machinery ran continuously once harvest began, and the smell of apples processing was sweet at first but became unpleasant as the season progressed. In 1983, Lamont Langworthy had the idea of creating artists' studios in the building, and in 1988, Atelier One became part of the Graton community. (Louise Hallberg.)

Hallberg's cannery was built in 1947, during the peak of the apple industry. A *Press Democrat* article from 1948 called the Green Valley area the "Most Concentrated Apple Area in all the World." It said that there were eight large and numerous small apple-dehydrating plants, providing nearly 25 percent of the nation's dried apples; three vinegar plants; a cannery; and three fresh apple-packing plants. The cannery was closed in the late 1970s; Chateau St. Jean bought the building in 1979 and converted it into a wine bottling plant. This picture was taken around 1994 prior to the building being remodeled by its next owners, the Associated Vintage Group. (Merrilyn Joyce.)

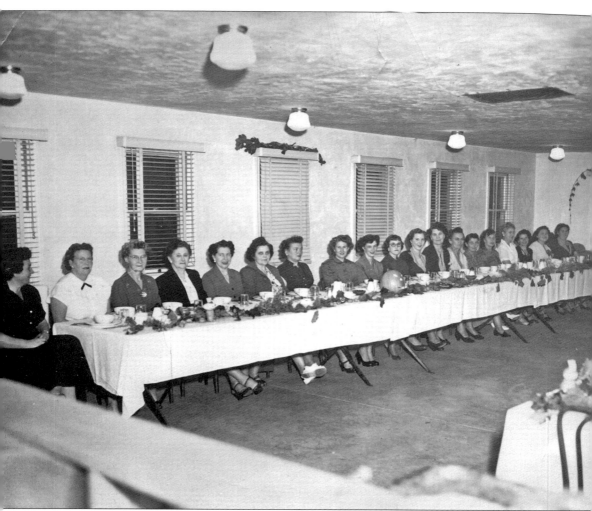

The employees of O'Connell's and Hallberg's were treated to a harvest dinner in the dining room of the cafeteria when the apple season was over. At that time, the profits from processed apples exceeded those from fresh fruit. It was considered a very special occasion where the female workers and male supervisors (it was 1954) dressed in their best. (Tanner family.)

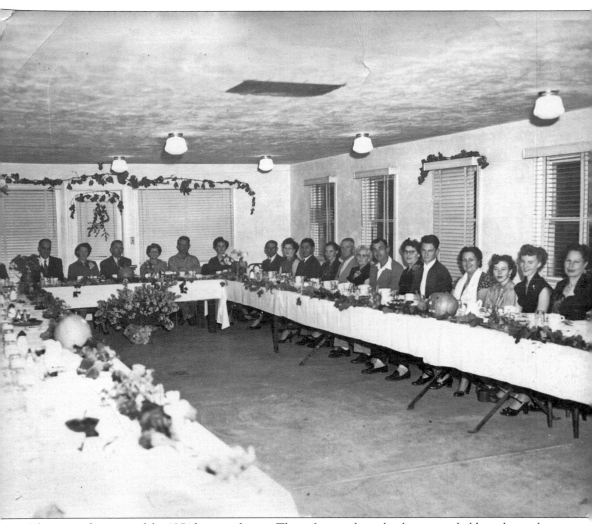

This is another view of the 1954 harvest dinner. The cafeteria where the dinner was held was located at the northeast corner of Donald and Bowen Streets. It is now a residence. (Tanner family.)

In 1950, after his dryer on Vine Hill Road burned, James O'Connell leased Oscar Hallberg's dryer. He processed apples there until 1979. In this photograph of him in 1955, he is standing before a group of his workers at a potluck lunch in the downstairs of the dryer celebrating someone's birthday, perhaps his own. (Tanner family.)

Lee Barlow and Martha Wilson are showing off apple slices sometime in the mid-1950s. In addition to apples, after World War II, hundreds of tons of government surplus potatoes were dehydrated to be made into potato flour. Some of Graton's dehydrating plants took advantage of the government's "potato deal" between apple seasons. (Tanner family.)

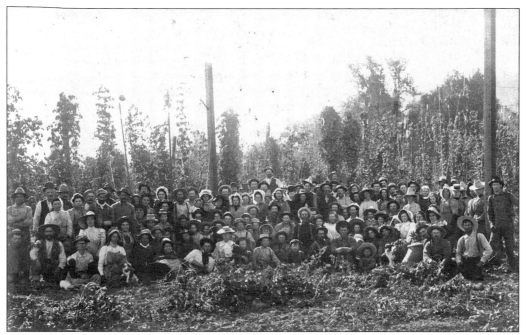

These hop pickers are assembled at the Clayton Winkler ranch in this photograph from around 1898. Clayton's hop fields were located where the Graton sewer pond is now. Asa Bushnell brought hops to the Green Valley in 1853, where they thrived until a mold began to appear in 1903. By 1919, when Prohibition began, the hop fields were gone. (Jim Winkler.)

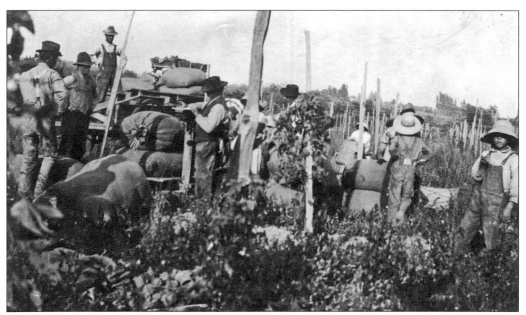

This 1915 photograph shows hops being weighed after the September harvest at the Hallberg Ranch. The hop pickers put the hops into burlap sacks and placed them on the scales, shown to the left, to be weighed. The foreman in the middle of the picture is writing down each the weight of each worker's bags, as hop pickers were paid by weight, not quantity. (Louise Hallberg.)

After the weights of each worker's bags were recorded, bags of hops were loaded on a wagon and taken to the hop kiln for drying, as shown in this 1915 photograph. These Hallberg Ranch hop pickers are hitching a ride on the bags. Picking hops was an equal opportunity job, with men, women, and children participating. (Louise Hallberg.)

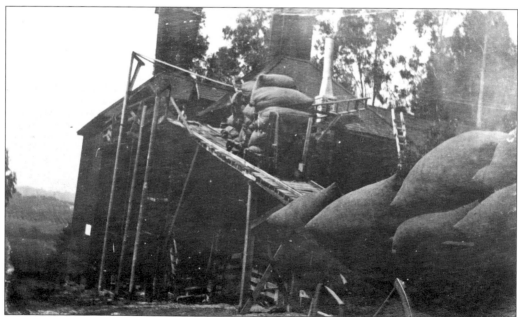

Burlap sacks of hops were loaded onto a small trolley, which was hoisted up the wooden ramp and into the hop kiln. Kilns had a drying floor about 20 feet above ground level. The hops would be spread across it at a depth of 1 to 2 feet and were dried with hot air from the furnace below. After about 20 hours, the hops would be bundled into bales and delivered to hop buyers. This photograph is of the hop kiln on the Hallberg Ranch in 1915. (Louise Hallberg.)

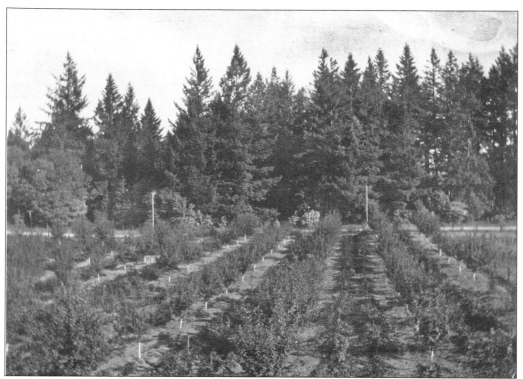

Berries were also a profitable Green Valley crop. They could be harvested before the apples or hops were ready. The Wirts family interplanted Mammoth berries with Gravenstein apple trees, as shown in this *c.* 1915 photograph, taken on the Wirts farm on Sonoma Avenue, looking north. Graton Road, unpaved, can be seen in the back, running along in front of the Graton Park grove of trees, eventually known as Handy's Grove. (Linda Stordahl.)

Cherries were the first crop to come in each year. In this 1912 photograph, Della Hallberg is picking cherries on a piece of land the Hallbergs called simply "Ten Acres." The cherry orchards were east of the Hallberg Ranch, in the spot along Gravenstein Highway (now Highway 116) where Gourmet Mushrooms, Inc., has been located since 1977. (Louise Hallberg.)

Clayton Winkler (center, far back) and three of his sons are standing in their peach orchard in 1898 or so. John H. Wiley began his peach orchard in the Green Valley with propagation from a single peach pit he brought with him from Virginia in 1850. By 1880, others had discovered Wiley's Graton Cling Peach, and so many orchards were planted from Occidental Road to Green Valley Road that the area was known as Peachland. Peachland almost became Graton's name, but it was discovered there was already a Peachland in California. By 1900, there were almost no peach orchards left in the Green Valley, from a combination of over supply resulting in low prices and a blight that caused massive tree death. The dead peach trees were converted by Italian laborers into charcoal, which was in demand for use in San Francisco restaurants. (Jim Winkler.)

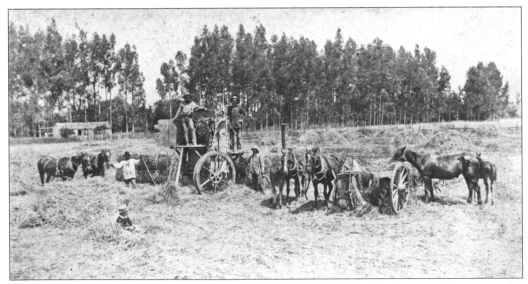

This *c.* 1910 photograph shows hay being harvested and baled with the use of horses on the Hallberg Ranch. Oscar and Alfred Hallberg are standing on the baler, and their father, John, is to the right. The identities of the small boy and the man holding the horse are unknown. (Louise Hallberg.)

Four

RELIGION AND EDUCATION

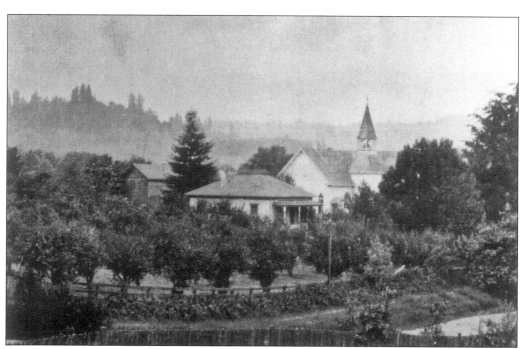

A Methodist church was built on Sullivan land on Green Valley Road in 1899. At the time, the area was still called Peachland. A parsonage was also built next door to the church for its minister, Rev. C. E. Irons. The church burned down in 1914, but the parsonage is still there, next to the Green Valley Cemetery. (West County Museum.)

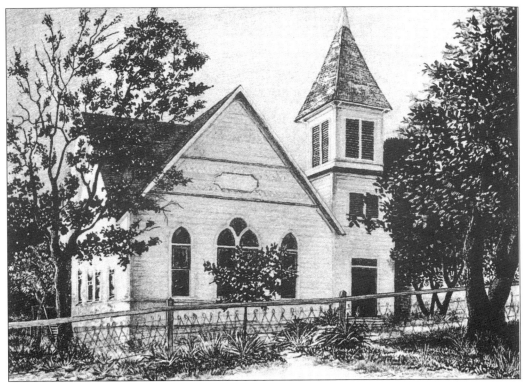

In 1899, Clayton Winkler donated land to build the Green Valley Congregational Church at the corner of Green Valley Road and what is now Highway 116. The church shared its minister, Rev. William Rogers, with Sebastopol Congregational. Both churches burned down in 1914, as did the Methodist church in Green Valley, and the Methodist churches in Occidental and Sebastopol. It was surmised that the fires were the work of arsonists, angry at the Women's Christian Temperance Union. The women of the churches were calling for an end to the use of alcohol, a sentiment that would not have gone over well in an area where many farmers and ranchers grew and sold wine grapes and hops. (Graton Community Club.)

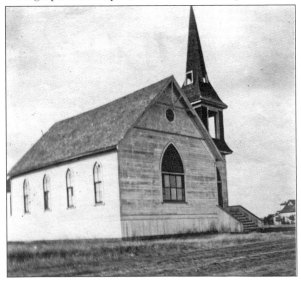

The Church of God was at the northeast corner of Edison and Irving Streets. It was built around 1909 and was still active in 1948. In 1950, the First Baptist Church started meeting just down the road. The Church of Christ on Donald Street had built a large new building, and the Graton Community Church was meeting on Ross Road. Membership at the Church of God declined, and in the early 1950s, the unused church was torn down. (Hazel Singmaster Jens.)

The First Baptist Church of Graton was founded in 1950 by Bennie Craven and his wife, Joy. The first meetings were held in a converted chicken coop on Gray Street, then in a member's home, until the church was built in its present location on South Edison Street. Vacation Bible School, held at the church for two weeks every summer, was a big part of many Graton children's lives. This 1968 photograph shows local children performing on the stage in the church sanctuary. The two little girls in matching dresses at the left are cousins Angela (left) and Laura Tanner. The area with the curtains behind the group is the baptismal font. (Tanner family.)

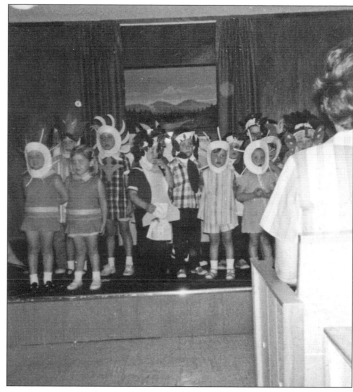

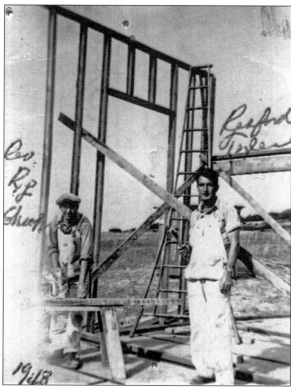

The Graton Assembly of God Church was called the Graton Community Church when it was first founded in 1946. Its meetings were held in the Graton Community Club until the current church building was constructed on Ross Road land donated by the Shook family. The church moved into the unfinished basement in 1948. This picture from 1948 shows Raeford Tyler and Rev. Roy Shook beginning the framing of the church. (Christine Hincher and Shirley Hayes.)

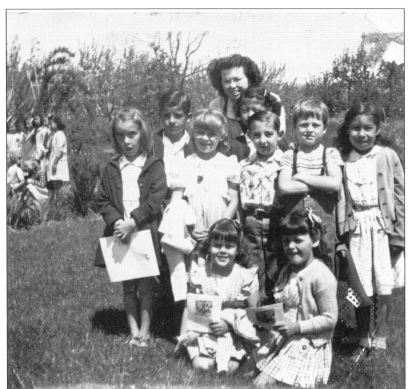

Reverend Shook's daughter Rosalyn stands with her Sunday school class in the late 1940s. In the front are twins Joyce and Janice Smith. In 1966, the church became the Graton Assembly of God, a gospel church. (Christine Hincher and Shirley Hayes.)

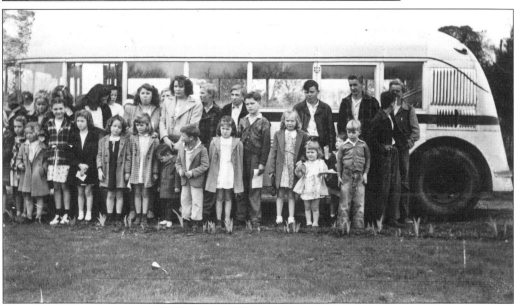

Roy Shook's daughter Mazie's husband, Clyde Stinnet, drove this bus around Graton gathering children for Sunday school at the Graton Community Church. This picture of local children standing by the bus was taken in 1947. There was also a fundamentalist church in Graton. Located on Graton Road east of Dyer, it was run by Reverend Dougherty, who owned the property. Locals called it a "one cupper" church because it was so small it took only one cup to pass around for the collection. The church building is now a residence. (Christine Hincher and Shirley Hayes.)

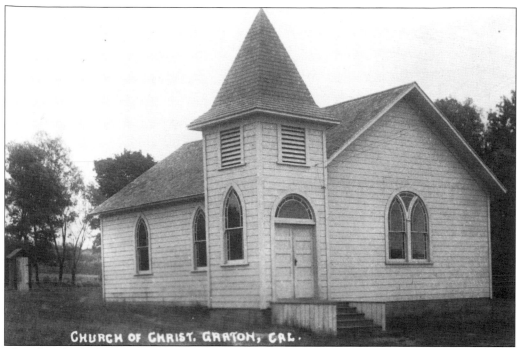

The Church of Christ was founded in 1909. In 1915, when this picture was taken, the church was located on Brush Street and had an outhouse behind it. In 1921, it was moved onto the Pacific Christian Academy campus and used as a classroom. (Frank Sternad.)

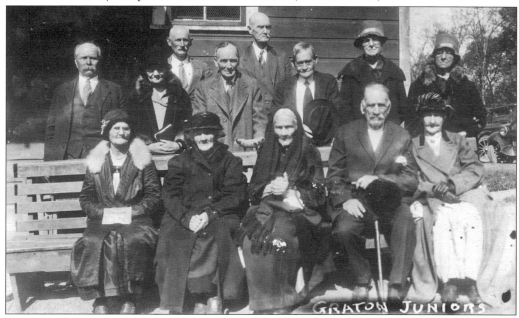

The Church of Christ elders are gathered together in this picture from the late 1920s, jokingly labeled "Graton Juniors." From left to right are (first row) Sister Goss, Grandma Bacon, Sister Smith, and Brother and Sister Porter; (second row) Brother and Sister Badger, Brother Johnston, Brother Griner, Brother Flesher, Uncle Barbour, Sister Coons, and Sister Sinclair. Their first names are unknown. (Chuck Lanier.)

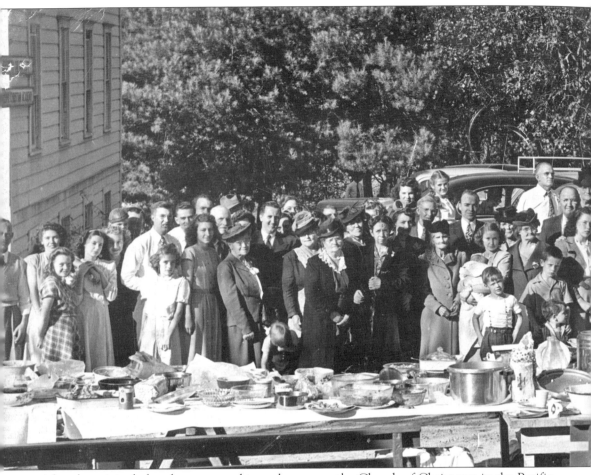

After the original church was turned into classrooms, the Church of Christ met in the Pacific Christian Academy school building. The entire congregation posed next to the building in 1947. The current Church of Christ building was constructed the following year at the southeast corner

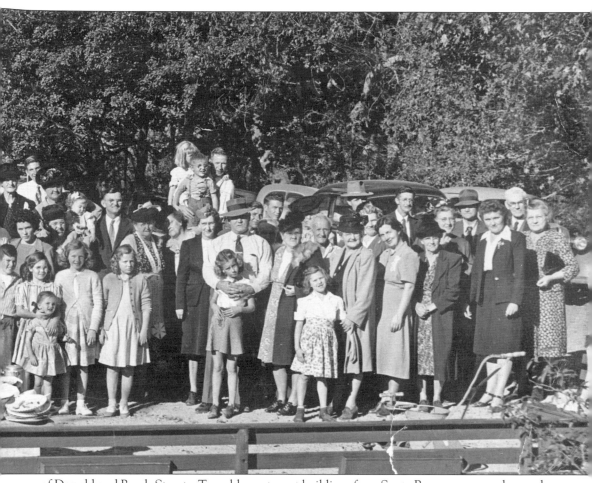

of Donald and Brush Streets. Two old apartment buildings from Santa Rosa were moved onto the site and remodeled into the church as it looks today. (Chuck Lanier.)

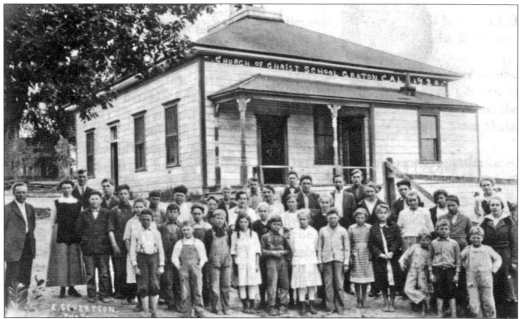

The Pacific Christian Academy was founded in Santa Rosa in 1918 and moved to Graton the following year. This photograph from 1920 shows the original Oak Grove School building from 1854 that was purchased and used for the new school. The following summer, the Marshall School building from 1860 was purchased by the Badger family and donated to the school. It was inserted under the Oak Grove building to create a two-story schoolhouse, with classrooms underneath and an auditorium on top. (Chuck Lanier.)

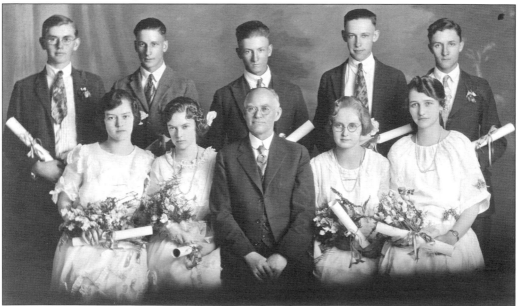

The first high school graduating class from Pacific Christian Academy was in 1923. From left to right are (first row) Theda Bailey Davis, Ethel Wiggins Dyke, principal O. W. Gardner, Dorothy Davis, and Mildred Barbour Davis; (second row) Harold Davis, Elden Stine, Francis Parham, Ivan Davis, and Athol Crowson. (Chuck Lanier.)

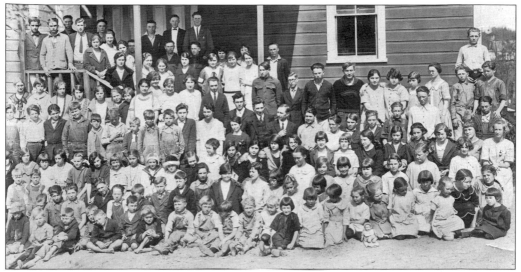

The entire student body of Pacific Christian Academy assembled for this 1924 photograph. PCA teaches students from kindergarten through high school, and they are not required to be members of the Church of Christ. In 1921, to meet the growing enrollment, the original Church of Christ building was moved onto the campus and remodeled into two classrooms. The Pacific Christian Academy Quilting Ladies met in the old church building and made quilts to raise money for the school. (Chuck Lanier.)

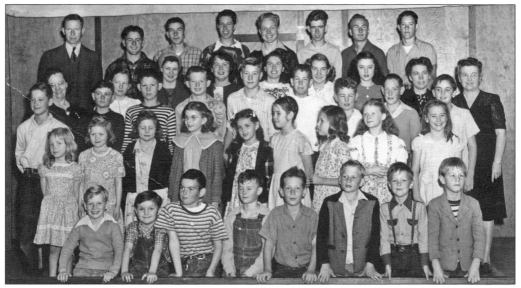

There are many familiar Graton faces in this 1948 Pacific Christian Academy photograph. From left to right are (first row) Chuck Lanier, Jimmy Davis, Dilford "Marsh" Harris, Jolly Christian, Billy Dykeman, Jim Lanier, Cliff Davis, and Bob Dykeman; (second row) Mary Moreland, ? Wofford, ? Wofford, Ruth Coburn, Gloria Davis, Jackie Koehlin, Patty Johnson O'Neill, Geraldine Rogers, and Carolyn Hayes; (third row) Ron Davis, two unidentified, Bill Poplin, Jerry Christian, ? Davis, Preston Jones, Clayton Davis, and Delbert Davis; (fourth row) Gertrude Muzzy, Lucy Moreland, unidentified, Loreen Brewer, Elsie Coburn, Lois Coburn, Billy Jean Davis, Ethel Lanier, and Sister O'Neill; (fifth row) Glenn Moreland, Dale Davis, Bob Coburn, unidentified, Ray Farmer, Pete Koehlin, Isaac ?, and Erwin Davis. (Chuck Lanier.)

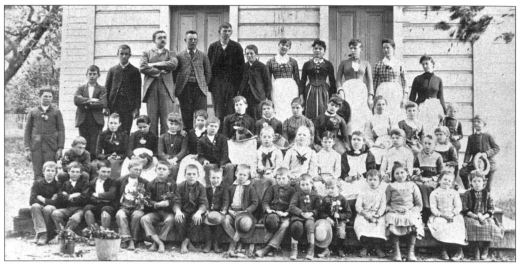

Oak Grove School was founded in 1854. The student body is assembled on the porch of the school around 1890. From left to right are (first row) Jack Wiley, George Ayer, Ed Hathaway, unidentified, Jesse Osborn, Will Coats, Fred Ward, Bert Ward, Ernest ?, unidentified, Albert ?, Edna Warren, Minnie A?, Dottie Rogers, and Clara R?; (second row) Mack and Lucy Graham, Ima Sullivan, Dora Rogers, Edith Ward, Warren Wiley, Alice Marshall, Lilian Rogers, Chet Hathaway, Alice Ayer, Emma Aitken, and Charlotte Ayer; (third row) two unidentified, ? Warren, Frances Thomas, Ora Thomas, Katy Abramsky, and ? Ayers; (fourth row) George Bower, Charles Perrier, Rowe Hathaway, Mr. Perry (teacher), Ben Sullivan, George Winkler, Dudley Aitken, Sadie Bower, Maggie Meyer, Hattie Winkler, Mary Bower, Mrs. Meek (teacher), Terry Coates, and Harold Atkins. (Jim Winkler.)

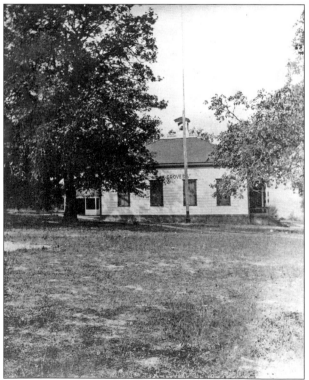

This is how the original Oak Grove School building looked in 1900. The first school in the Green Valley was Ash Spring, founded in 1852, which was built where the Gilliam Cemetery is now on Sullivan Road. People on the east side of Atascadero Creek did not like having to cross the creek to get to school, so they formed their own district and started Oak Grove School in 1854, and the Ash Spring school closed. (Louise Hallberg.)

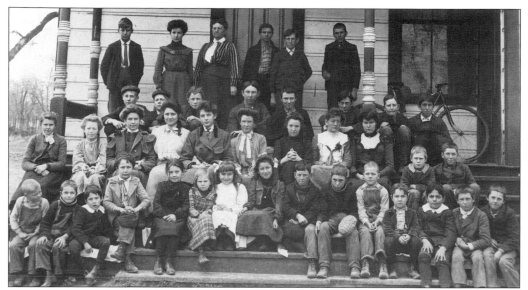

The students of Oak Grove School posed on the steps of the school in 1905. Pictured are, from left to right, (first row) George Heintz, Floyd Gardner, Eugene Carrillo, Clarence Bower, Fern Hawn, Susie Hudspeth, unidentified, Ida Baldwin, Roy Peake, Roy Gardner, John Heintz, John Wirts, Lawrence Carrillo, Roy Rambo, and James Hudspeth; (second row) May Hudspeth, Cora Miller, Ida Hallberg, Grace Gardner, Florence Winkler, Hallie Rambo, Alazuma Wirts, Adella Warner, Christina Marshall, Alvin Hawes, and Milton Rambo; (third row) William Roaf, Bertram Bower, Howard Leigh, Ralph Janes, William Hawes, Edward Wallen, Charlie Marshall, and Harry Baldwin; (fourth row) Oscar Hallberg, Elsie Rickard, teacher Mary B. Williams, Edd Hudspeth, Kenneth Bryant, and Clay Gerard. (Louise Hallberg.)

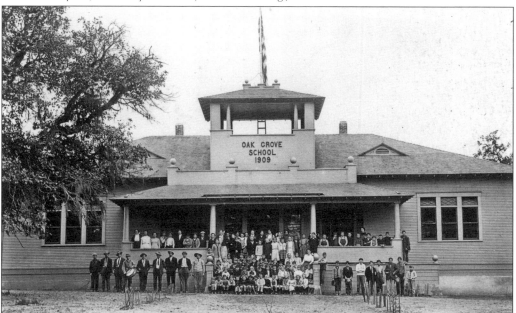

In response to Graton's growth and the school's increasing enrollment, Oak Grove built a new school building in 1909. The entire enrollment is gathered in front of the beautiful building. The original bell was installed in the cupola on the roof. (Hazel Singmaster Jens.)

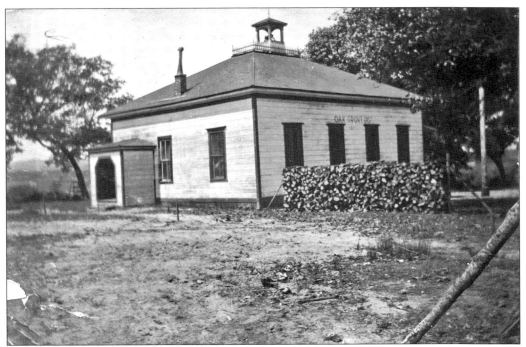

This photograph of the old Oak Grove School building was taken in 1910. The school was used as a residence for a while before being sold to the Pacific Christian Academy. (Louise Hallberg.)

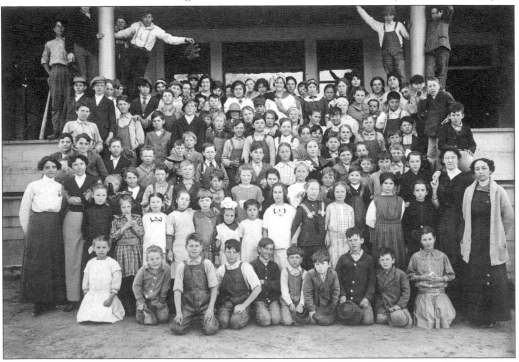

The students in this 1913 photograph are not identified, but the Oak Grove teachers were, on the left side, from left to right, Myrtle Rhodes and ? Dow, and on the right side Daisy Johnston and ? Treadway. (Hazel Singmaster Jens.)

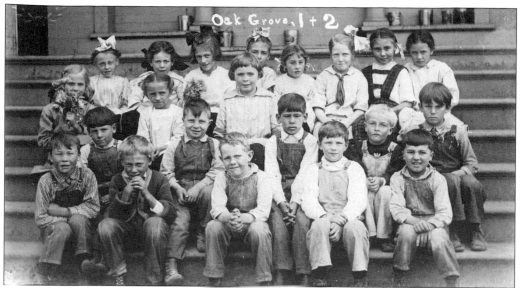

Oak Grove's first and second graders posed together on the steps of the school in this postcard image from around 1920. The students are unidentified. (Hazel Singmaster Jens.)

The 75th anniversary of Oak Grove School was marked with a Diamond Jubilee celebration in 1929. In the chair is Mrs. Otis Allen (Harriet Sebring), age 84, who attended the school from 1854 to 1860. Her son George Allen attended Oak Grove also, as did her grandson Harry Allen and her great-grandson Walter Allen. All four generations attended the celebration, though the younger Allen men are not in this picture. Sen. Herbert Slater was the speaker. Among the alumni gathered here were (in no order) Elizabeth Carrillo; Cornelius Gilliam Sullivan; Oliver, Ed, Jesse, and Rollo Winkler; Oscar and Alfred Hallberg; Sophronia Sullivan Street; Mary B. Williams (teacher); Eleanor Purrington Rued; Bertram Bower; Irene Marshall Maddocks; and Alazuma Wirts Singmaster. The front porch of the school was now enclosed. (Hazel Singmaster Jens.)

A group of early-1920s unidentified upper-grade Oak Grove students are gathered by one of the oak trees in front of the school. The baseball player on the far right is one of the Winkler boys. (Hazel Singmaster Jens.)

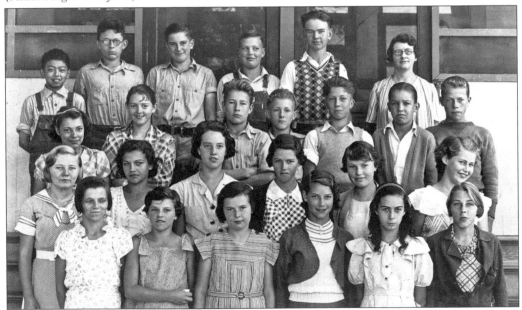

This photograph from 1934 shows a class of students in the middle grades. Pictured are, from left to right, (first row) Dorothy Moore, LaVerne Strough, Lois Seigle, Lois Tallman, Claire Elder, and Helen Roberts; (second row) Muriel Hawes, Laura Workover, Bernice Stockhurst, Evelyn Young, Wilma Johnson, and Jean Gerald; (third row) Norma Mathis, Ann Fouts, ? Rowland, Dee Anderson, Marion Bank (?), Jack Blackwell, and Herbert Dalbom; (fourth row) Fumio Sako, Robert Siegle, Wallace Winkler, Ellis Peterson, Stanley Ketchum (?), and their teacher, Buelah Lance. (Jim Winkler.)

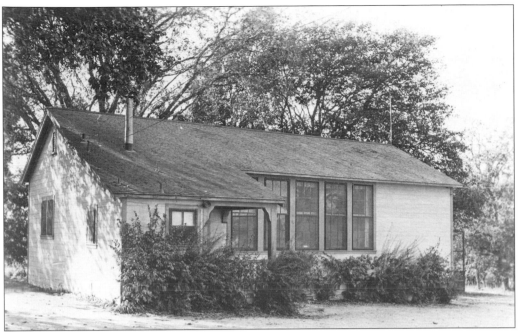

In 1934, the primary-grade classroom was built at Oak Grove School using WPA labor. The WPA, or Works Progress Administration, was part of President Roosevelt's New Deal to put people back to work after the Depression. The building was used as a classroom and music room and in later years was called the "scout hut" when the Boy Scouts met there. It is now the site of Childkind preschool and day care. This photograph was taken in 1949. (Hazel Singmaster Jens.)

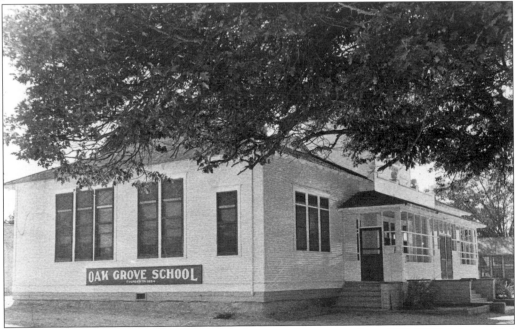

The Oak Grove School building looks brand-new in this picture from 1935. WPA labor spiffed up the school building, doing some repairing and repainting. The Oak Grove School sign on the side of the building now hangs in Louise Hallberg's barn. (Louise Hallberg.)

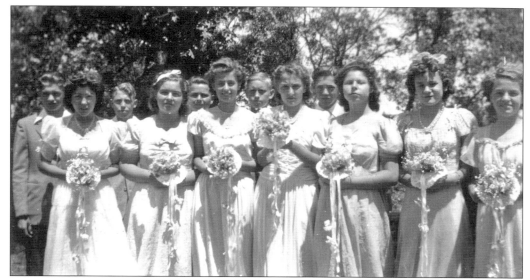

Oak Grove School's eighth-grade graduating class of 1943 held its graduation ceremony in the grove of oak trees for which the school was named. The students are, from left to right, (first row) Rose Cordoza, Virginia Hodges, Phyllis Robertson, Billie Prosser, Virginia Bates, Joyce Morris, and Virginia Nott; (second row) James Meredith, Earl King, Wesley Walker, Earl Suddeth, and Lishal Kitchens. (Phyllis Welsh.)

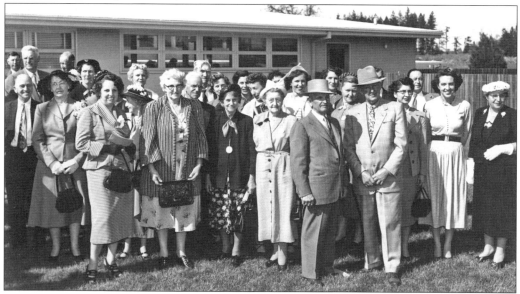

Oak Grove School's 100th birthday was celebrated on the new campus in 1954. The new buildings were completed in 1952, and the original bell was installed in a monument at the front of the campus. From left to right are (first row) Art Malm, unidentified, Hazel Kaufman Asbom, Alazuma Wirts Singmaster, Mamie Wedge Harmon, Jennie Winkler Williams, William Hotte, and Walter Winkler; (second row) Robert Hallberg, Oscar Hallberg, Roy Gustafson, Vivian Arnold Winton, Doris Neep Brock, Manuel Wedge, unidentified, Mary Temple Asbom, Martha Temple, Martha Singmaster Rogers, Doris Stockhurst Kennedy, Jane Stevens, Marie Rather Harris, Rebecca Banks-Kidwell, unidentified, Bernice Stockhurst, and Grace Marshall Prosser. (Hazel Singmaster Jens.)

The cover of the Oak Grove yearbook for the 1962–1963 school year shows the front of the school as it looked then and the original bell. The Oak Grove School Association was very active in the school from about 1923 to 2005. OGSA (as it was called) put on many school activities, such as mother-daughter fashion shows, father-son dinners, and annual Halloween carnivals. Through the years, the organization raised thousands of dollars for school improvements and offered a variety of community building activities. Oak Grove School now has an active Parent Teacher Organization still raising money to benefit students. (Jim Winkler.)

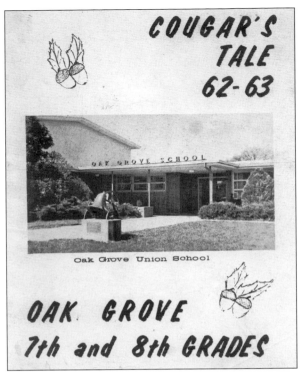

OAK GROVE 7th and 8th GRADES

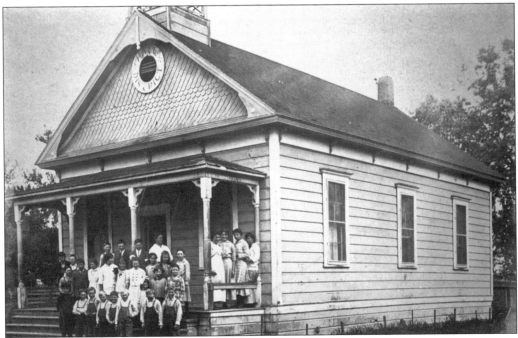

The Hall School District building was sold to Phyllis and Warren Welsh in 1951 after the school incorporated into the Oak Grove School District. This photograph is from the 1890s. The building still stands on Hall Road near Willowside School, which was built as a middle school for the Oak Grove District in 1965. The Welshes built their home on the original Hall School site after moving the building west about 50 yards. (Phyllis Welsh.)

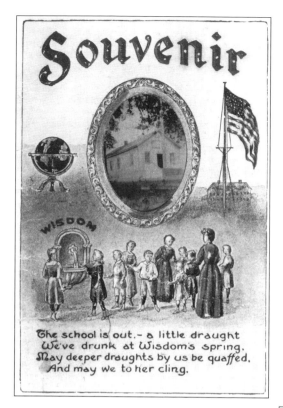

Souvenir

WISDOM

The school is out.- a little draught
We've drunk at Wisdom's spring.
May deeper draughts by us be quaffed.
And may we to her cling.

Green Valley School was built on land donated in 1866 by Lancaster Clyman. Winthrop Maddocks was in charge of the construction, and the school was completed in 1867. The first school building burned down and was rebuilt in 1929. The first two teachers were Thomas Alley and May Wheeler. The original school building can be seen on this 1908 cover image, from a souvenir booklet given to graduating students. (Sue Davis.)

This photograph from the 1940s shows the Green Valley School building that still sits on Green Valley School Road. The school was consolidated into the Oak Grove School District in 1964, and in 1969, the school building was deeded to the Graton Fire Department. It was used by Head Start in the 1970s and 1980s and is now used as a polling place during elections. (Sue Davis.)

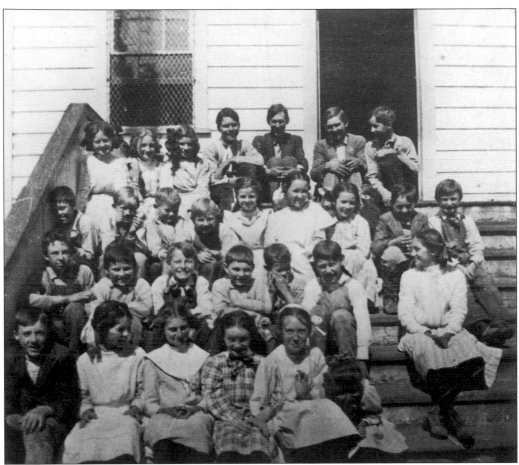

The students of Green Valley School are gathered on the steps of the original building in this photograph from 1911. Pictured are (first row) H. Colburn, Hazel Churchman, Marie Giovaninni, Marjorie Treadway, Phoebe Tallman, and Louise Rayner; (second row) ? Rayner, Oscar Ludolf, Albert Klotz, ? Colburn, ? Davis, Al Gerhardt, and Rena Giovaninni; (third row) ? Rayner, Jack Wiley, ? Davis, Carl Gerhardt, Mary Hooper, Ruth Churchman, Lois Discher, Louis Maddocks, and Carl Klotz; (fourth row) Harriet Maddocks, Ann Gerhardt, Mattie Archambeau, George Giovaninni, Laurel Tallman, Fred Gerhardt, and Wink Treadway. (Bud Chenoweth.)

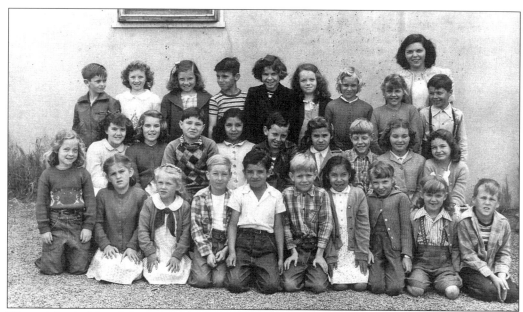

This is Marabel Losch Pozzi's class from around 1949. Pozzi had the distinction of being the only former student of the school to return as a teacher. Another teacher, Clement Young, who taught in 1890, went on to become governor of California in 1926. (Sue Davis.)

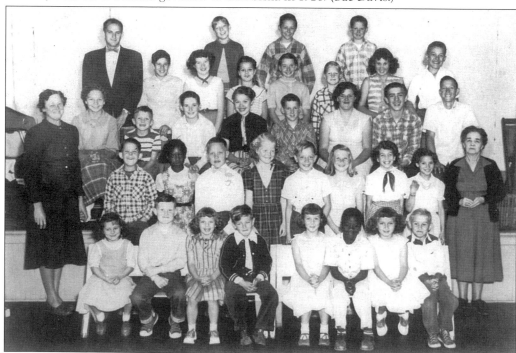

In its later years, Green Valley School was organized into four lower-grade classes and four upper-grade classes. It had a small football and baseball team and even a few cheerleaders. Eighth-grade graduations were held on the stage at Analy High School in conjunction with other small districts like Occidental, Vine Hill, and Jonive. This school photograph is from 1955. Green Valley School has been holding reunions at Chenoweth Woods since 1948. (Sue Davis.)

Five

ALL AROUND THE TOWN

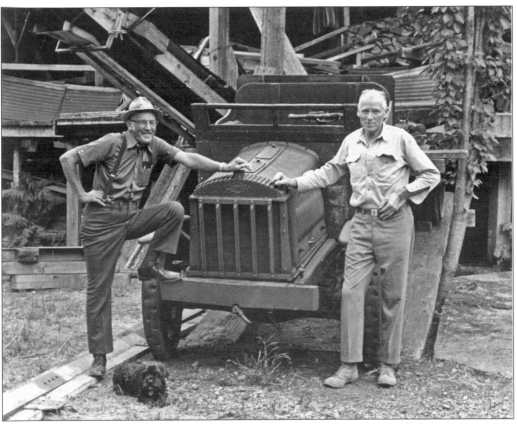

James Henningsen (left) and Ralph Sturgeon were partners in Sturgeon's Mill from 1943 to 1964. The steam-powered sawmill was originally built in the 1880s at Korbel. In 1913, Wade Sturgeon, Ralph's father, purchased it from Melvin "Boss" Meeker and moved it to the Coleman Valley site where Wade began his lumber business in 1914. In 1924, he moved the mill to Green Hill Road, which runs between Graton and Occidental Roads. Ralph and James bought it from him in 1943. The mill closed in 1964, and James passed his half on to his son Harvey Henningsen, who took this photograph of the old friends in 1974. In 1993, a 30-year reunion of former mill workers was held, and afterward Ralph, his sons Bob and Dan, Richard Trevicheck, John Barber, Virgil Shaw, and Harvey Henningsen each laid a $100 bill on the hood of Ralph's 1949 GMC pickup and made a commitment to restore the mill. The mill now has demonstration runs open to the public four weekends a year, with the goal of becoming a working museum. (Bob Sturgeon.)

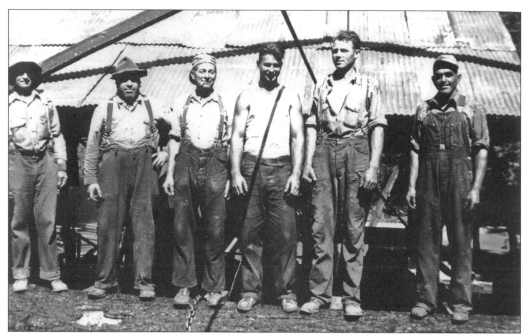

These men are taking a break from working at Sturgeon's Mill to have their picture taken in 1947. From left to right are Wade Sturgeon, John Gonnella, Bert Fagge, Ken Sullivan, Ralph Sturgeon, and Nicio Gedotti. Now a large crew of volunteers and benefactors keep the mill going. (Bob Sturgeon.)

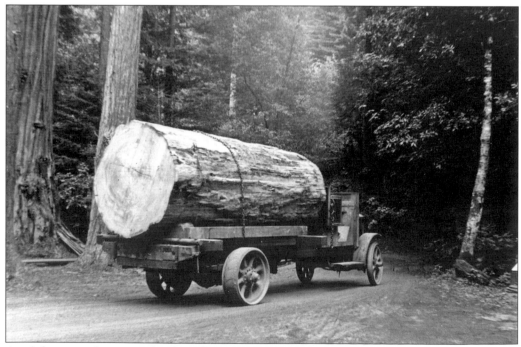

A solid tire truck was used to haul logs. Regular single tires would have blown out under the weight of the logs. This 1924 Dorris hauled a huge fir log to Sturgeon's Mill in 1947. The truck is still in use at the mill today. (Bob Sturgeon.)

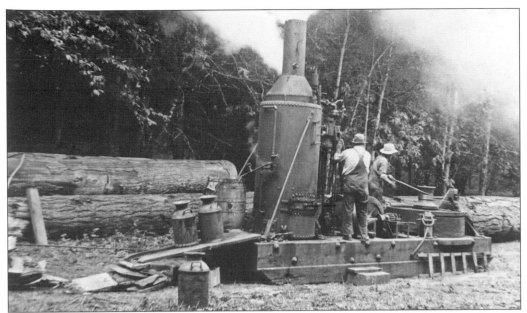

A 1905 Willamette steam donkey replaced the work of real donkeys and mules. It was used to pull the felled and cut logs to a central landing where they were hoisted onto trucks and hauled to the mill. The back of John Gonnella can be seen as he runs the engine, while an unidentified man controls the cable. Eventually gas engine tractors replaced steam-powered donkeys like this one, but this one was still in use at Sturgeon's Mill in 1947 and may someday be restored. (Bob Sturgeon.)

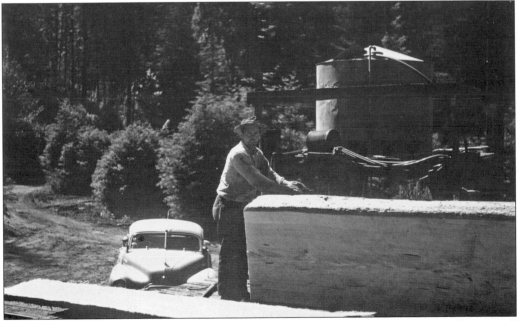

Chenoweth's Saw Mill on Green Valley Road was in operation from 1952 to 1963. The sawmill was located on the Chenoweth Ranch. In this picture from the late 1950s, Earl Long is standing by a log on the carriage that just came back from a cut. The cut slice is laying in the foreground. (Bud Chenoweth.)

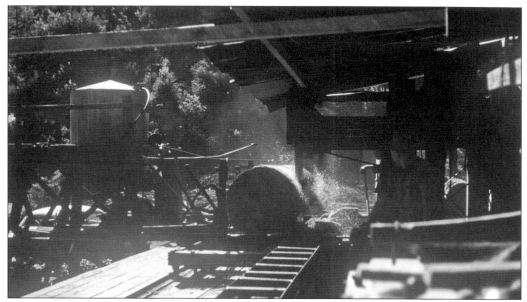

Logs are laid on the carriage and moved through the saw to be rough cut. The cut boards are then sent to a planing mill to be refined into smooth lumber. Bud Chenoweth is supervising the operation of the mill, but his outline is barely visible on the right. Bud is the son of Leland Adelbert "Del" Chenoweth and Ann Gerhardt, both descendants of Green Valley pioneer families. The Gerhardt Ranch was renamed the Chenoweth Ranch in 1943. Chenoweth Woods, located on the ranch near the sawmill site, is a popular location for weddings, picnics, and reunions. (Bud Chenoweth.)

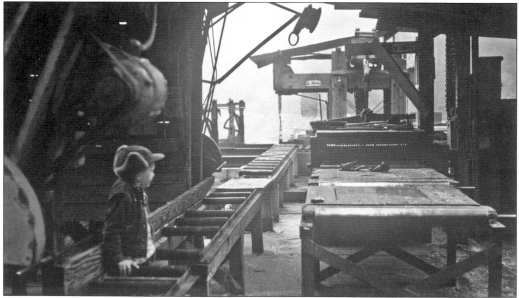

Chenoweth's Mill is not in operation as Mike Lane stands between the rollers that the log carriage slides down. Bud bought the parts for his mill at the old Friedman Brothers store in Petaluma, along the Petaluma River. It was not uncommon for ranches to have their own mill. In the late 1940s, John and Jack Robertson made portable mills for sale using salvaged parts and taught purchasers how to use them. (Bud Chenoweth.)

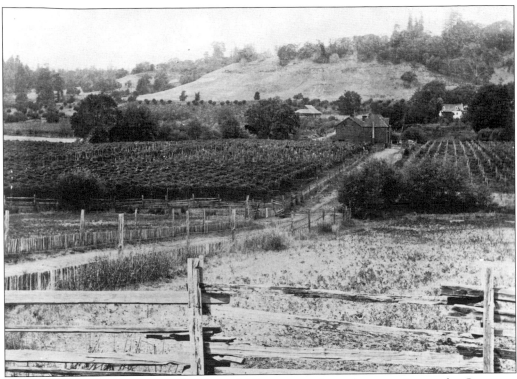

The Purrington family came to the Green Valley area at about the same time as the Gregsons, Sulllivans, and other pioneers. Their ranch was west of the Sullivans' land. Joseph and Frances Purrington's son Sam built the first hop kiln in the Graton area. The road from one of the Purrington ranches into Graton was known as Purrington Road until around 1950. It is now Railroad Avenue. This photograph from around 1905 was taken from above Graton Road looking east at the Purrington Ranch. (Bob Sturgeon.)

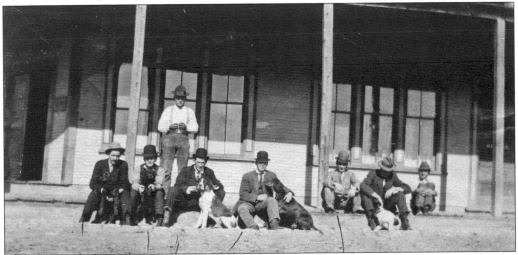

A group of Graton men are showing off their dogs on the steps of the hotel in downtown Graton in 1908. From left to right are (seated) unidentified, Frank Wirts, Tallon Barnes, Roy McAnnich, Clyde Ward, Erroll Singmaster, and unidentified; (standing) unidentified. Clyde Ward was a county supervisor at one time. (Hazel Singmaster Jens.)

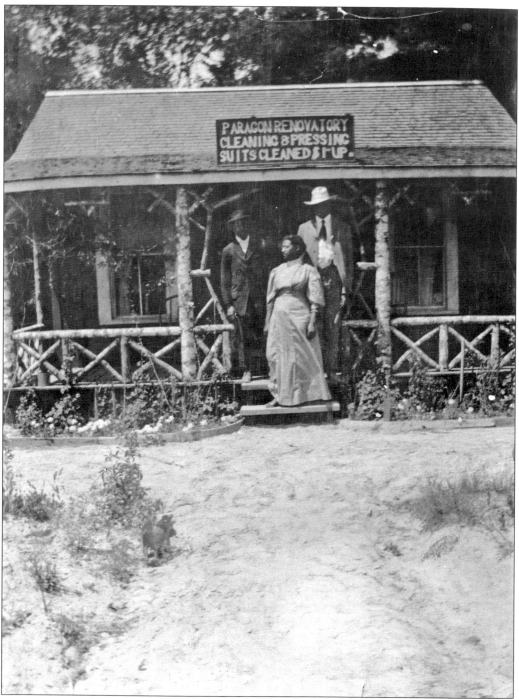

It was unusual to see a business owned by African Americans in the early part of the 20th century. This photograph from 1910 is of a cleaning establishment on the north side of Graton Road, east of town. The sign reads, "Paragon Renovatory, Cleaning & Pressing, Suits Cleaned $1.00 Up." This building is now a residence on Graton Road but no longer has the wonderful log porch railing. (Louise Hallberg.)

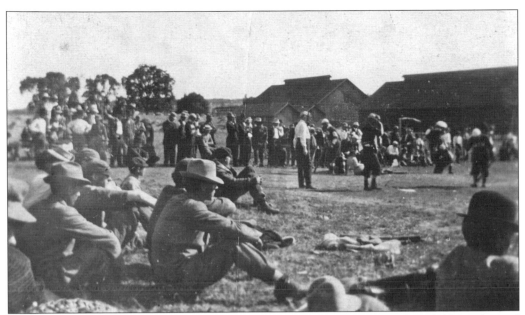

A group of spectators is watching Graton's baseball team play in 1911. Their field was located between Edison and Bowen Streets, a block south of town. The buildings in the background are T. L. Orr's winery. A poem by Ruth Sinclair was published in the *Press Democrat* about a game they played against Duncan's Mills. It concludes, "The result of the game is history, the score was four and five. Duncan's have to feed 'old Bill,' but Graton's still alive." Old Bill refers to their mascot, a billy goat. The team's colors were blue and white. (Hazel Singmaster Jens.)

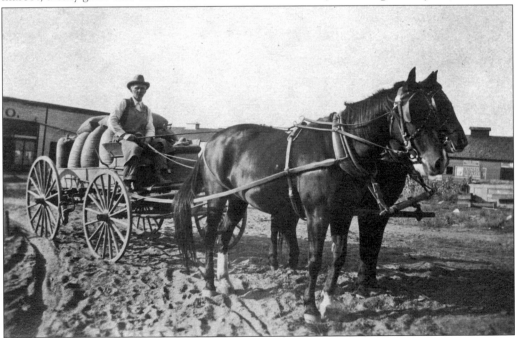

John Ramsey has his wagon loaded with feed from the feed store located by the railroad tracks in Graton. This photograph was taken in 1911. Ramsey worked for Charles Hallet in the general store. (Phyllis Welsh.)

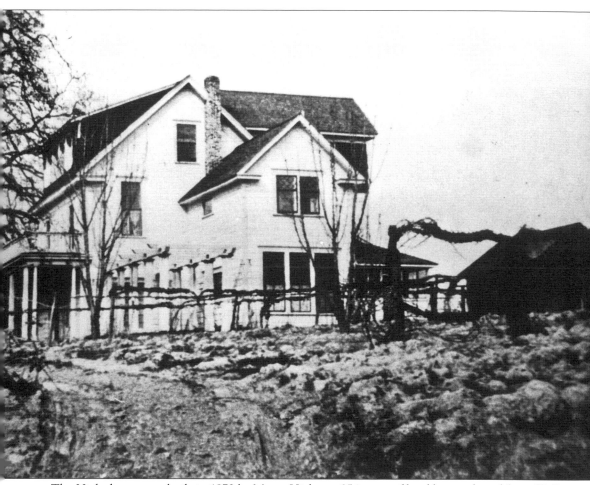

The Hicks house was built in 1872 by Moses Hicks on 354 acres of land he purchased from W. B. Clement. The three-story Greek Revivalist–style house was purchased by James Gray and his wife, Jeannette, along with the land, in 1904 for $2,500. Gray moved the home up 300 feet northeast of its original location using logs and mules. The property was subdivided into the town of Graton, and the Grays lived in the house. The house was sold to Fred Maddocks in 1913. He lost the house to the bank in the financial climate of the 1920s. In 1931, John and Fannie Deegan became the owners, then in 1956 the Kelly family. From 1958 to 1969, it was owned by Loren and Cora Lee Walters, and after that, Robert and Emily Lynde and their six children. After the Lyndes' divorce, the house went through a series of renters and was in sad shape when Don and Jacque Mielke bought it in 1985. They renovated and restored the house into a bed-and-breakfast called the Gravenstein Inn. They used columns from the torn-down Bank of Sonoma County building in Sebastopol to rebuild the main porch. In 1994, the present owners, Frank and Kathleen Mayhew, bought the house, and it is again a private residence. (Kathleen Mayhew.)

These children are in a pumpkin patch near downtown Graton. The Church of Christ building can be seen in the background. In 1919, when this photograph was taken, the church was located on Brush Street. The children in this picture are, from left to right, (seated) Hazel Singmaster and Alfred Neep, who was named after his grandfather; (standing) Louise Hallberg, Bob Neep, Doris Neep, and Ida Neep. (Louise Hallberg.)

A group of Graton area teenagers gathered for this 1923 picture. From left to right are (first row) Jack Robertson, Frank Christensen, Ellis Alderson, and Tom Greene; (second row) Waunema Jones, May Hawkins, Alice Ross, Dorothy Widdoes, Doris Hutcheon, and Frances Jones. (Phyllis Welsh.)

The Heralds (on the porch) owned this beautiful house on Brush Street. They were benefactors of the Church of Christ and donated the land where the church now sits. The house has been owned since the 1970s by Paula Magyari. This photograph shows how the house looked in 1930. (Chuck Lanier.)

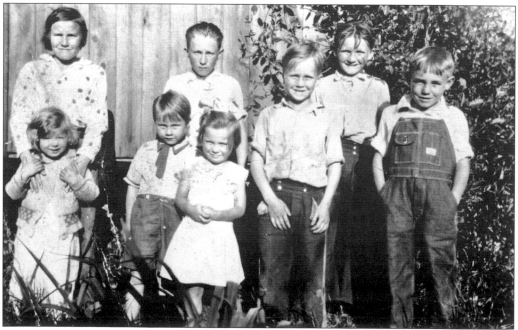

In 1932, a group of Graton children gathered for Phyllis Mae Robertson's third birthday party. From left to right, they were Alene Baker, Phyllis Mae, Loy Curtis, Johnny Curtis, Arice Osborn, Wendell Curtis, LaVerne Curtis, and Carl Baker. (Phyllis Robertson.)

Ruth Ellen Gardner is standing on the east side of Edison Street with Shirley Street visible behind her. In 1939, there was a white wooden fence around the culvert that takes the creek running along Shirley Street under Edison Street. The house behind her and its privy no longer exist. In the 1970s, goats lived in the field after all the buildings were gone. (Buck Gardner.)

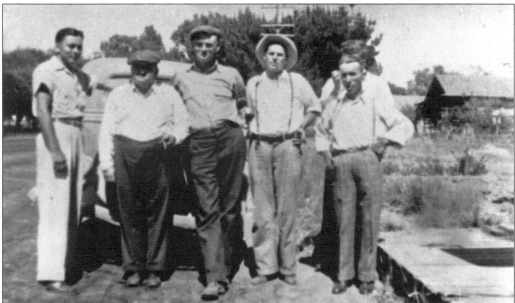

All small towns have their town characters. One of Graton's was Barney Voncannen, who lived in a rental cabin downtown and had no teeth. He is standing with this group of Graton men in 1935. From left to right are unidentified, Babe Stevens (who owned the bar at the southeast corner of Main and Edison Streets from the 1930s to the 1960s), Barney, Pat Gardner, Pete Garrison (obscured, in the back), and Bob Rogers, who was a foreman for Oehlman's. In the 1970s, the town character was Arthur Doneza, a developmentally delayed man with some missing teeth and a big grin. He rode around town on his bike, honking the horn Judy Tanner gave him to keep him from getting hit by a car, as he tended to veer into the road. (Buck Gardner.)

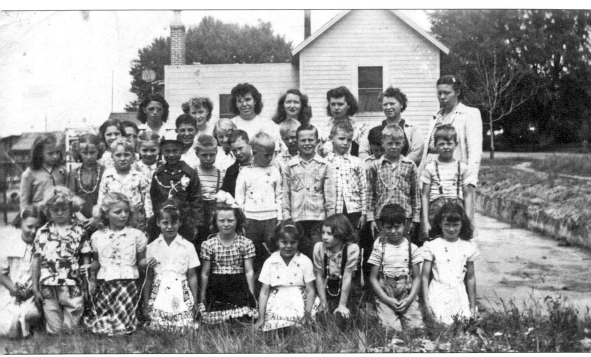

Oak Grove students would take walking field trips to the Eaty-Beady candy factory on Vine Hill Road. This group stopped to pose for a picture on Main Street in Graton in 1949, the same year the factory burned down. Most of the students are wearing their candy necklaces. They are gathered where the Russian River Bakery stood before it was destroyed by fire in 1928. The house behind them was the home of the bakery owner, Dan Longbrake. The house was expanded in later years, and from the 1990s until 2005 or so, Far Fetched Jewelry had its jewelry business there. Shown are, from left to right, (first row) Alma Shepherd, two unidentified, Janice Smith, Marie Dougherty, Joyce Smith, Christine Clark, Danny Tinney, and Judy Schaefer; (second row) unidentified, Ruth Clark, unidentified, Shirley Baker, Melvin Wong, unidentified, Allen Bartlett, unidentified, Benny Jones, unidentified, and Charles Fontaine; (third row) Loleta Metzger, unidentified, Dwayne Walker, Opal Bartlett, Marshall Jones, unidentified, and Barney Keifer; (fourth row) ? Shepherd, unidentified, ? Smith, ? Clark, unidentified, Mabel Shepherd, and ? Tinney. (Christine Clark.)

A group of Camp Fire Boys and Girls are on an outing near Sturgeon's Saw Mill in 1940. Alice Ross Robertson was their leader. From left to right are (first row) Alice Auger; (second row) June ?, Josh Garrigan, Selma Wilson, Tracey ?, Bruce ?, LaVerne Curtis, Walt Garrison, and Lucille Garner; (third row) Calvin Johnston, Phyllis Robertson, Harold Moore, Rosie Cordoza, Pete Heflin, Ruth Gardner, Lois Tibbs, Thurman Moore, Omega Moore, Glen Long, and Edward Long; (on the left fence post) Leland Auger. (Phyllis Robertson.)

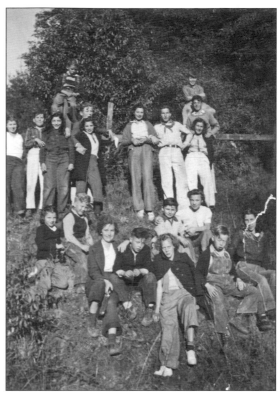

Brothers Arthur "Bob" (left) and Lee Walker are riding on Vine Hill Road in 1942. Their grandfather, Arthur Upp, came to Graton in 1908. He owned Upp's Pharmacy in Graton until the early 1930s. Lee and Bob are also descendants of pioneer John Walker, who came to the Green Valley around 1850. When Lee Walker married Shirley Chaney in 1953, they moved to the Upp Ranch on Graton Road and it became Walker Ranch. They ran a fruit stand from 1968 to 1970 on Earl Carrillo's property at Vine Hill and Green Valley Roads but decided to sell apples from home instead, and they have been packing and selling apples at Walker Ranch ever since. (Lee and Shirley Walker.)

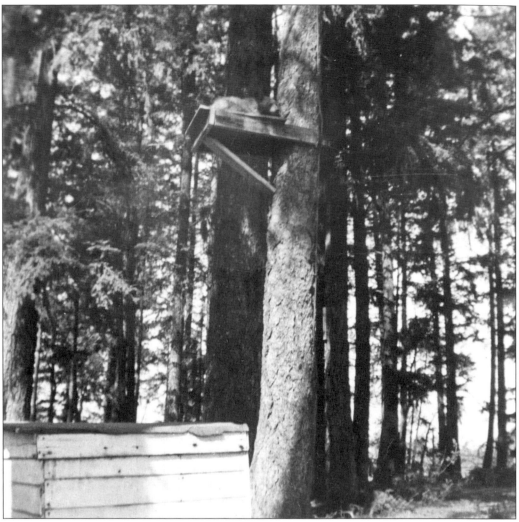

Pete Garrison bought Handy's Grove around 1950. At that time, it still had a campground, picnic area, and gas station. It also had a small grocery store, a country western bar, and a bear. The bear was the sole survivor of the zoo started by Roy Handy. When Jack Robertson leased the gas station and campground back in 1932, the bear was young. One day, when Jack could not find his then three-year-old daughter Phyllis, he went looking for her and found her out back playing with the bear. The bear was kept chained to a platform built onto a tree, and it could freely climb up and down. When this picture was taken around 1954, the bear was at least 23 years old. California black bears can live more than 25 years in the wild, so it may have been much older. Rumor has it that some years later, Pete got tired of the bear, and bear barbecue was served one night at the bar, but there is no proof of that. (Larry Tanner.)

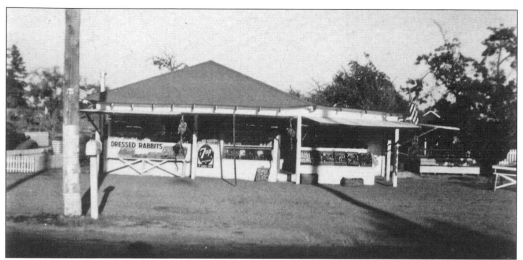

Joe and Viola Paul bought Dickey's fruit stand and property at what is now the northeast corner of Highway 116 and Vine Hill Road in 1945. They called it the J and V Ranch. They sold live rabbits that they would kill and dress, bananas, and fruit they grew themselves, such as apples, prunes, cherries, plums, and pears. In the mid-1950s, they had a lunch counter. Art Paul, Joe and Viola's son, and his wife, Barbara, packed and sold apples and juice there until the mid-1980s. They also had a welding shop. In 2000, they put in some grapes for an amateur wine competition. Like many farmers, they began to convert apple orchards into vineyards, and in 2005, they started the Graton Ridge label. Art and Barbara remodeled the juice barn into their winemaking facility and, in 2007, remodeled the packing barn into Graton Ridge's tasting room. (Art and Barbara Paul.)

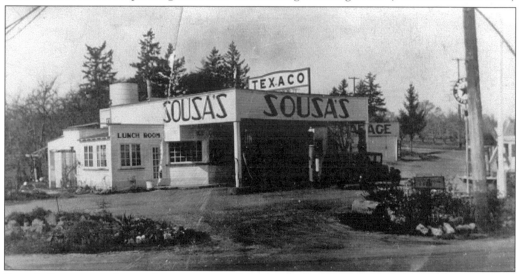

Sousa's Corner was the southwest corner of the triangular intersection at Vine Hill and Green Valley Roads. After Ed Sousa sold the old livery stable building in downtown Graton in 1930, he built the gas station, grocery store, lunch room, and garage along what was then Gravenstein Highway. Next to it was a fruit stand rented by the Wheelers. Behind the business was Sousa's campground, where "fruit tramps" and families who came to work the harvest would camp. Sousa's Corner closed in 1963 when the O'Connell family bought the property, probably around the time Gravenstein Highway/Highway 116 was moved to its present location south of the property, diverting all the through traffic off the old roadway. (Sousa family.)

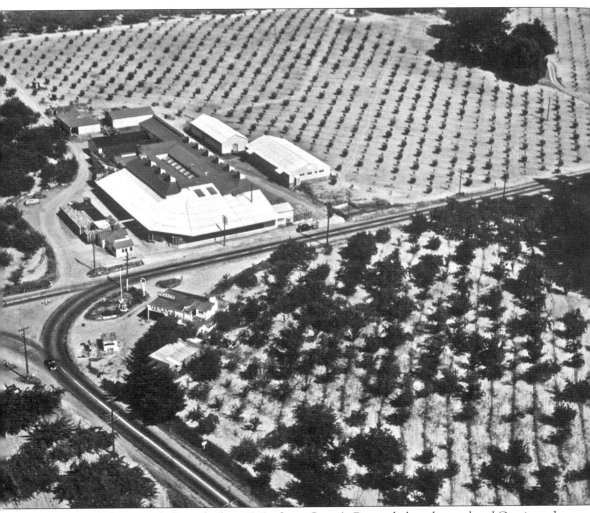

This aerial photograph from the late 1940s shows Sousa's Corner below the road and Garcia and O'Connell's plant above the road. The little windmill in front of Sousa's was attached to a cage that once held a monkey and later held birds. The large building in the middle of O'Connell's was where they manufactured Eaty-Beadys, round candies wrapped in cellophane and made into a necklace. In 1949, the factory burned down along with the fruit dryers. James O'Connell leased Oscar Hallberg's dryer in town but still shipped dried apples and fruit from here. It is now the hydroponics plant. The apple trees, newly planted when this picture was taken, are still there. The area below the road is now the Davis Christmas Tree Farm. Not visible in this picture is the large grove of fir trees that made up O'Connell's Grove. From 1973 to 1975, concerts were held in the grove. Folks came from all over to sit on hay bales and listen to performers like Kate Wolf and Don Coffin. (Sousa family.)

Molino Grocery, Deli, and Gas Station was located at Molino Corner, the northwest corner of Highway 116 and Occidental Road. In 1979, when this photograph was taken, it was owned by the Warren family from Occidental. Years earlier, the Hickory House, a bar that served breakfast and lunch, was across the street. It burned down in the late 1960s. The Molino Corner building burned down in December 1982. It is now the site of Husary's 76 station. George Husary had a store in downtown Graton from 1971 until the late 1980s. (West County Museum.)

George Smith came to Graton from Los Angeles in 1954. George worked in the movie industry and had a collection of movie props and artifacts. He and his family built a replica of a late-1880s Western town on his ranch near the Laguna de Santa Rosa and stocked the buildings with goods and equipment from the late 1880s and early 1900s. They used salvageable parts from old houses torn down around Graton to add an authentic feel to "Georgetown." This portrait of George is from 1995. He died in 2001. (Guy Smith.)

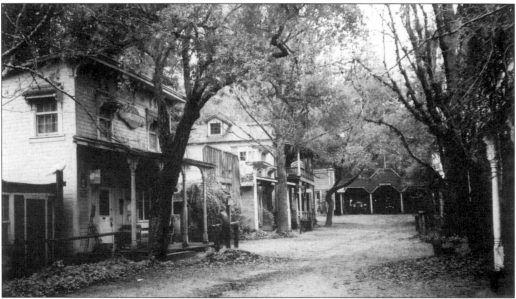

Walking the street in Georgetown is like stepping back in time. Guy Smith, the late George Smith's son, now keeps Georgetown going. A buggy from *Gone With the Wind* is stored in the carriage house along with other horse-drawn carriages. Every building is unique and holds antiques and collectibles. Many car clubs like to meet at Georgetown and peruse Guy's collection of antique vehicles. Tours of Georgetown are by appointment only, and it is occasionally rented for use in movies and television. (Guy Smith.)

Six

ONLY IN GRATON

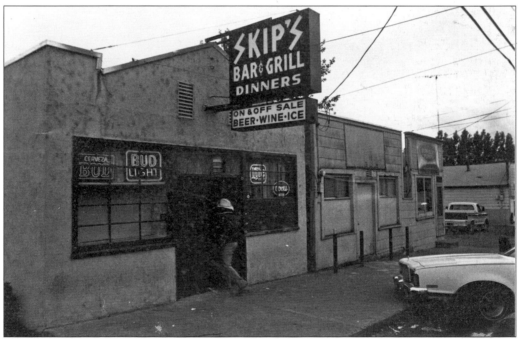

For many years, Skip's Bar and Grill was the most famous place in Graton. This photograph shows the bar in the early 1970s. The buildings on the right are the old shoe store and the former barbershop. Skip's was founded by Skip Henderson in the late 1930s or early 1940s. Nick Pavoni bought it on August 16, 1959, when he was 21 years old and ran it until he sold it in 1993. It remained Skip's for a while under the new owner, was briefly a restaurant called Passionfish, then was bought by Lulu Spittles and Matthew Greenbaum, the owners of the Willow Wood Market and restaurant, who remodeled it into the Underwood Bistro. (Nick Pavoni.)

Skip and Peggy Henderson were given a going away party and some luggage when they sold Skip's in 1959. The bar's jukebox is to the left. The mounted fish on the wall advertises "Burgie!" (Burgermeister) beer. The building where Skip's was located was constructed in 1935 after the two-story building on the site burned down. The first structure was known as the Kimes building; the fire that destroyed it also destroyed the Camp Fire meeting house behind it. (Nick Pavoni.)

The interior of Skip's bar in the early 1970s was typical of many small-town working-class bars. There was a pool table in the back, the ladies' room had a hand-printed sign, and a pay telephone hung on the wall. The jukebox and cigarette machine were on the left. The menu was up on the wall with a chalkboard underneath to write down any specials, like an abalone dinner if someone had a good day at the coast. Kids were allowed to hang out in the bar to play pool, pinball, and eventually video games. (Nick Pavoni.)

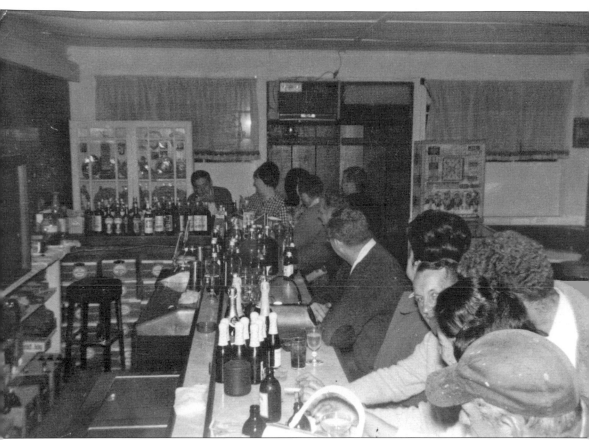

One evening at Skip's in 1969, a French Basque man named Albert Bidegan, who was married to Roma Jones, started shaking dice with Nick Pavoni for items from the bar. At the time, the liquor license only allowed the sale of wine and beer products. Albert was having good luck, and Nick started lining up his winnings along the bar. Everything shown on the bar here was won by Albert Bidegan that night, except for other customers' personal possessions. Bottles of wine, champagne, beer, cigars, and cigarettes were all won, and as the night wore on, bags of potato chips were added to the pile. Albert, shown seated at the end of the bar in front of the abalone shell case, loaded everything up in his fancy car and headed toward San Rafael on the freeway. About halfway there, he rolled the car, and everything he won was ruined. (Nick Pavoni.)

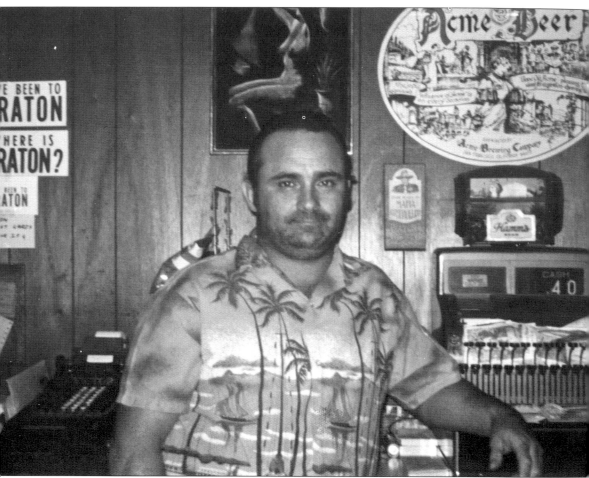

At Skip's bar in the 1970s, the money was still put in an old-fashioned cash register and the day's receipts were totaled on a hand-crank adding machine. Nick Pavoni was not yet 40 years old and had been through many adventures at the bar. The apple industry was fading away along with downtown businesses, and only Skip's, and the other two bars in town, were flourishing. Graton had a bad reputation because of the many migrant workers from Mexico hanging out downtown, the strong apple-processing smells, and frequent brawling. Skip's, however, remained a haven for locals, an extended family that looked after each other and celebrated birthdays and anniversaries at the bar. (Nick Pavoni.)

I'VE BEEN TO GRATON

In the 1970s, "I've Been to Graton" bumper stickers and postcards were sold as a fund-raiser for a Graton park. The logo was created by Oak Grove student Robin Averbuck. In 1973, a group of Graton parents met at Oak Grove School and decided to create a place for Graton's children to play. Charles and Violet Chapin donated some land across the creek from Pacific Christian Academy on Donald Street, and the rest was purchased with money raised from bake sales, a walk-a-thon, and the first Graton Fourth of July Festival, which was held downtown. The land was purchased in 1974, and volunteers began building the park. (Judy Tanner.)

At the Graton Fourth of July Festival in 1974, Fifth District supervisor Ernie Carpenter (rear, center) supervised the water balloon toss, held in the field between Edison and Bowen Streets. Supervising at the front of the row of kids was Eric Koenigshofer. The 1975 Fourth of July Festival was held at the park, and Kate Wolf and Don Coffin performed. The festivals featured crafts, a flea market, live music, food, beer, and lots of games and contests for children. (Judy Tanner.)

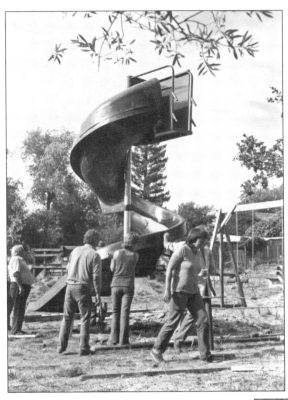

The 1976 Bicentennial Fourth of July Festival, held in the closed-off two blocks of downtown Graton, was a huge success. A handmade quilt featuring scenes from Sonoma County was raffled off, and a dunk tank and money wheel were part of the fun. Enough money was raised to finish the park, which was officially dedicated in September 1976. A twisty slide was installed with the help of, from left to right, Charlie Chapin, Jim Tanner, Judy Tanner, and Barbara Turner. (Judy Tanner.)

The Graton park was named Chapin Park in honor of Charles and Violet Chapin. They sent this Christmas card the year the bridge and sign were completed, before any play equipment was installed. The Graton park began to be neglected in the 1980s as the children of the parents who created it grew up. In 1987, the land was donated to Oak Grove School. The school sold the land and used the money to create a large soccer field on the school grounds. It is called Chapin Field. (Nick Pavoni.)

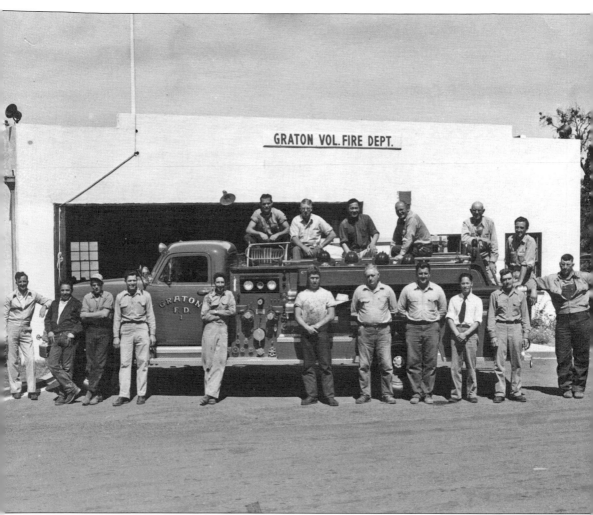

Graton has always had volunteer firefighters, but the fire district was not officially organized until 1951. The firehouse was built around 1945. In the civil defense era of the 1950s, the firehouse was stocked with government surplus equipment. The siren was designed to be heard across the 25 square miles of the district. In Graton's early days, fires were fought using the "fire-piece," a 50-gallon drum of water mounted between two wagon wheels with a hand pump and 100 feet of hose. It had a bar across the back and could be pushed or pulled. It was not very effective. These are members of the Graton Volunteer Fire Department in 1953. From left to right are (first row) Ezra Armstrong (fire chief), Leonard Mendoza, Buck Gardner, Jim Worthington (assistant chief), Andy Neal (assistant chief), Walter Garrison, Sam Keeler (Chinese district supervisor), Don Hallberg (supervisor), Jim Wong, Thomas Glynn, and Bob Hallberg; (on truck) Paddie Gardner, Jack Robertson, Paul Dunn, John Johnson, Bob Longwill, and J. C. Armstrong. (Phyllis Welsh.)

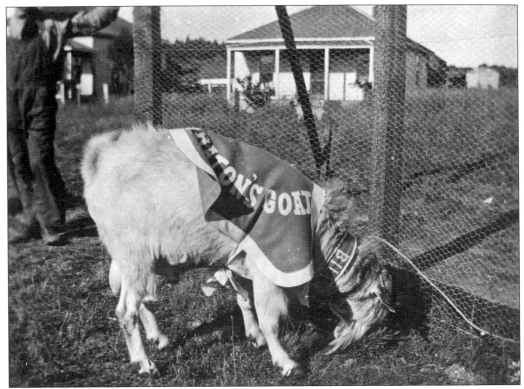

In 1911, Graton's baseball team had a mascot, Billy the goat. His coat and collar were blue and white, the team's colors. The houses in the background are 216 and 218 South Edison Street. (Hazel Singmaster Jens.)

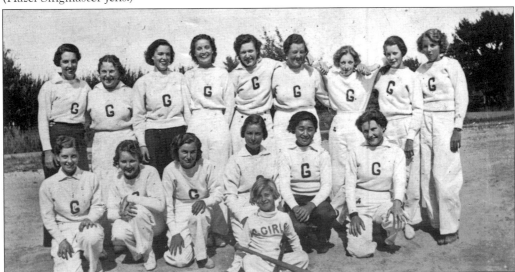

The Graton girls, known as the "G" girls, had a softball team in 1935. Jack Robertson was their coach, and his four-year-old daughter Phyllis was their mascot. The members were (not in order) Alene Baker, Helen Roberts, Evelyn Douglas, Dodie Stockhurst, Bernice Stockhurst, Virginia Nussbaum, Berla Beckman, Dorothy Kabuke, Elaine Carmody, Dorothy Bagent, Adele Blackwell, Ellane Kinder, Grace Carmody, Lois Tallman, and Aletha Tallman. (Phyllis Welsh.)

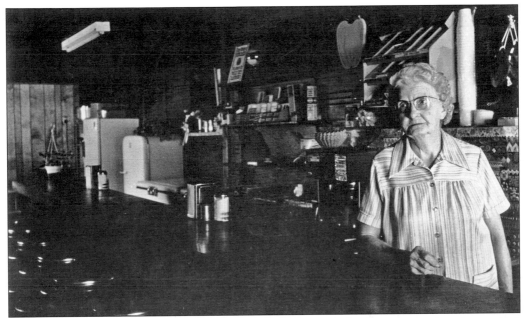

Myrtle Baker ran Baker's Service Station and Lunch from 1942 until her death in 1995. After her husband Earl's death in 1965, Myrtle ran her downtown business alone. For many years, if someone called the fire department, he or she got Myrtle, who turned on the siren. Her gas pumps were shut down in 1990, and the town deteriorated around her, but she kept serving breakfast and lunch to her regulars, and one could still shake her dice for the cost of the meal. Now Baker's sits deteriorating while the town has been revitalized around it. (Shirley Weeks.)

George Donner's great-grandfather Jacob died in the Donner Party tragedy in 1847. George's grandfather, also named George, was nine years old when he was rescued. He moved to Sonoma County 20 years later and died on his farm near Freestone in 1874. His grandson George Donner worked for O'Connell's from 1953 until he retired in 1973. He was a World War II veteran and lived on Sullivan Road until he died in 1993. George was celebrating his 84th birthday when this picture was taken in 1992. (Shirley Widdoes.)

Children's book author Jonathan London moved to Graton in 1987, and his sons went to Oak Grove School. In 1999, he was interviewed by local author Jonah Raskin, a Green Valley resident since 1975, at the Willow Wood Market and restaurant. The Graton area is home to many writers, artists, actors, and musicians. (Merrilyn Joyce.)

Graton's Jason Lane grew up on Oak Grove Avenue, and he and his twin Jonny graduated from the Oak Grove School District. Jason was a standout player in El Molino Little League, then at Santa Rosa Junior College, then at the University of Southern California. After playing Triple A, he got called up to the majors in 2003 and, in 2005, played in the World Series with the Houston Astros. Jason and his family still live in Graton. (Phyllis Welsh.)

JASON LANE

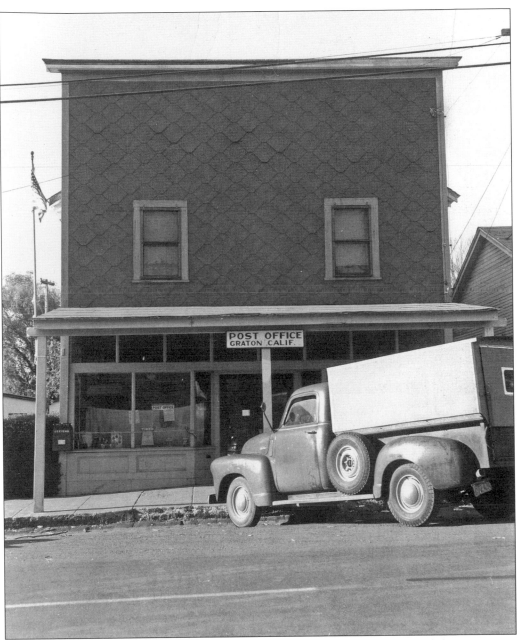

In 1906, John Robertson saw the need for a post office in Graton. He contacted the postmaster general, who said John would have to establish that there were more than 3 miles between Graton and the already existing post offices in Forestville and Sebastopol. John measured the circumference of the wheel on the family buggy, tied a red cloth around the rim, and as his sister-in-law Donna Gamsby drove the horse with the postal inspector beside her, he counted the revolutions of the wheel to measure the distance. He was able to prove that Graton's distance from Forestville was 3.3 miles, and from Sebastopol it was 3.7. Legend has it that he came up short on the way to Forestville and took a slightly different route back. John Robertson was named Graton's first postmaster. This photograph was taken in the 1950s. (Graton Post Office.)

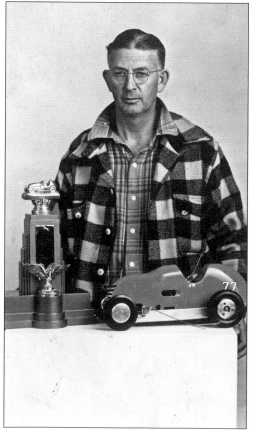

The new post office was dedicated in 1970, and postmaster Herman Biggers was presented with John Robertson's framed postmaster's certificate from 1906. John's son Jack is shown holding it in 1999. In 1916, the post office safe at Hallet's store was blown open and robbed of $400 by a group of Yeggmen. Yeggmen was a term coined for a group of professional thieves who preyed on small towns, sending out a scout in the daytime to assess the situation, then returning at night with an automobile to break in and steal from their chosen target. The Yeggmen had hit Guerneville the day before. (Phyllis Welsh.)

In the late 1940s, Jack Robertson was the president of the Santa Rosa Model Racing Car Association. Cars were raced on a cement track near the Coddingtown Airport in northwest Santa Rosa. A car was tethered to a pole in the track's center with a steel wire and timed as it raced around. There were no remote controls in those days. The car was switched on and push started. To turn it off, Jack held his hat down, and as the car raced by, his hat would hit a wire sensor sticking up from the vehicle and trigger the off switch. He set the world record speed of 127 miles per hour. (Phyllis Welsh.)

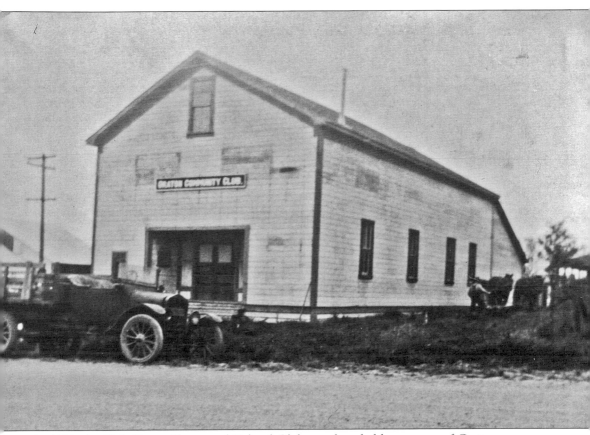

In 1914, the Oak Grove Home and School Club was founded by a group of Graton women. Teacher Daisy Johnston, Mrs. John (Jessie) Robertson, Cora Barr, and Mrs. O. M. Winkler made up the committee to draft the constitution and bylaws, and Ida Ramsey was the first president. The group met at Oak Grove School and hosted a series of fund-raisers. In 1916, they purchased the Incubator Building and land, located on the west side of the railroad tracks, for $500 and began holding their meetings there. Later that same year, the Sebastopol Apple Growers Union offered the club $425 for the land. The building was moved up the road to the northeast corner of Edison and Main Streets, using rollers and four horses. This photograph from 1925 shows the building in its new location. In 1923, a school association was founded at Oak Grove and the club changed its name to the Graton Community Club. Alfred Hallberg donated the sign. (Graton Community Club.)

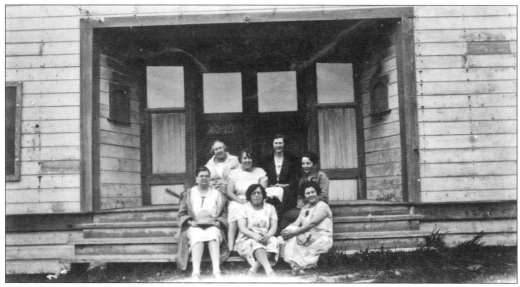

The former Incubator Building was placed on the lot backwards, so at first the only entrance to the Graton Community Club was from the rear. In 1924, the building interior was lined with tongue-and-groove paneling and a front entrance was created. The officers of the club gathered on the front steps in 1928. Shown are (first row) Mrs. J. H. Nimmo, Mrs. Ed Sousa, and Sara Brush (president); (second row) Mrs. Arthur Upp, Mrs. C. E. Hallet, Margaret Upp Walker, and Emma J. Howard. (Hazel Singmaster Jens.)

Mrs. Joe (Sara) Brush, Graton Community Club president in 1928, is turning over a ceremonial first shovelful of dirt before a remodel and expansion of the club building. A dining room and kitchen were added along the eastern wall of the building, and the stage was raised to its current height. The club building was almost lost to fire in 1970, but Nick Pavoni of Skip's saw a glow in the garden area, called the fire department, and ran over with his fire extinguishers from the bar and held the fire at bay until they arrived. (Hazel Singmaster Jens.)

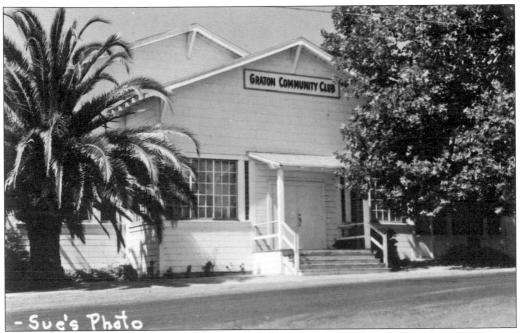

This postcard shows the Graton Community Club in 1959. The palm tree died in a hard frost in the early 1990s. In 1922, the members of the club voted to have a flower section, start learning about flowers and their cultivation, and someday hold a flower show. In 1923, a "Dahlia Tea" was held at the club. Oak Grove students presented a short program, prize dahlias were displayed, and tea and cake were sold. The ongoing tradition of flower shows at the Graton Community Club was born. (Graton Community Club.)

By 1959, the Graton Community held two-day spring and fall flower shows. Local students were invited to come see the shows before 10:00 a.m. on the first morning. Every show had a different theme and different chairmen. Every member was required to bake a cake to be sold by the slice and do an arrangement for the show. From left to right, Pearl Wong, Mrs. Merle Emerson, and Sara Brush are posing together to advertise the fall flower show with the theme of "Country Gardens." Crafts were now sold at the shows, which also featured a luncheon. (Graton Community Club.)

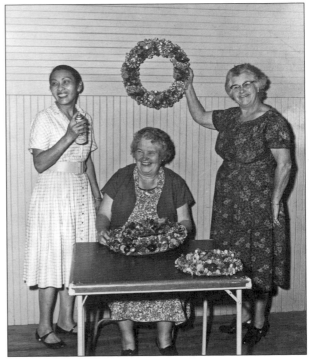

At the Graton Community Club's April meeting in 1969, a handmade Easter bonnet contest was held. Members wore their creations to the meeting, and prizes were given for most outlandish, most original, and so on. The winners are standing holding their prizes. From left to right are two unidentified, Florence Maddocks, and Alice Perry. (Graton Community Club.)

Melba Flesher and Gail Dutton are standing together at a 1987 flower show. The arrangements behind them were made to be sold. Since 1953, the Graton Community Club has used its profits to give annual scholarships to Santa Rosa Junior College graduates who are continuing their education. The club is a nonprofit organization and, in addition to scholarships, raises money to maintain their building, which is rented to community members for exercise classes, educational meetings, weddings, and other celebrations. Flower shows, in conjunction with the sale of plants, crafts, and secondhand items and a luncheon, continue to be held twice a year. The members of the club are still asked to bake a cake and embroider tea towels to sell. (Graton Community Club.)

Seven

DECLINE AND REBIRTH

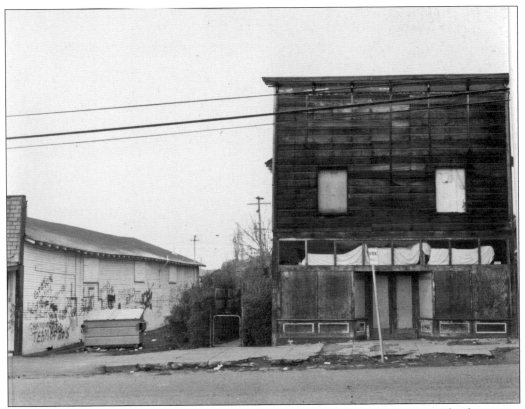

By 1990, Graton was described as a "ghost town" by an article in *Sonoma Business*. The downtown businesses were mostly closed, and all the buildings were ramshackle. To outsiders, the town looked completely dead, but locals knew it still had a vital heart. In this 1994 photograph, the post office building, once the site of Heintz Hardware Store, had its front windows boarded over and no paint. The Stop and Shop market on the left was open, but the former home of Spooner's and Hallet's was covered in graffiti. The sidewalks were broken and uneven, the edges crumbling. (Merrilyn Joyce.)

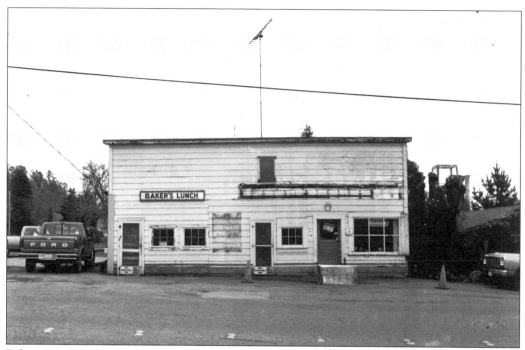

Baker's Lunch was still open for breakfast and lunch in 1993, but not for much longer. The awnings were torn off the building when the gas pumps were removed in 1990, and after Myrtle Baker's death in 1995, the former livery stable was left empty. (Merrilyn Joyce.)

In 1993, Turner's Automotive was open for car repair, but the gas pumps were removed in the late 1970s. El Tenapa, the bar on the southeast corner of Main and Edison Streets that replaced Babe's, had burned down in 1981 but had been rebuilt and was in its last year of operation. (Merrilyn Joyce.)

The once proud Union Block building was a sad remnant of its former self in 1993. After Elmer Crowell owned it in the 1930s, it was owned by Ray Matthews and became Ray's Place; then Louie Mouc bought it and called it Louie's Place. At some point, the upper story and most of its windows were removed, and the outside was covered in stucco. In the 1990s, it became El Corral. (Merrilyn Joyce.)

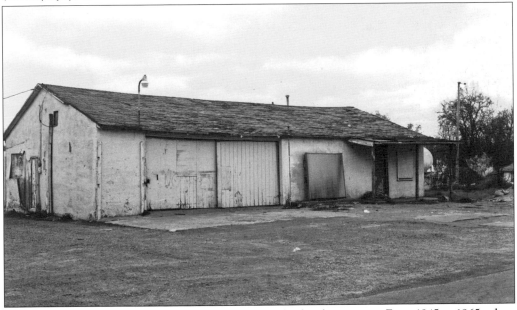

Bill Boykin's garage and gas station was next door to the fire department. From 1945 to 1965, when someone called the fire department, they got Boykin's, and he or his wife, Mildred, would go next door and sound the siren. Myrtle Baker took the job over when the Boykins sold the garage. The business remained open under new ownership, but the gas pumps were pulled out in the 1970s, and eventually, like many buildings in town in 1993, it sat abandoned. (Merrilyn Joyce.)

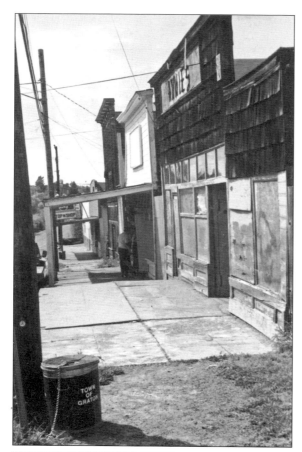

Annie's building was Robertson's Groceteria, then Paul's Market and Moore's Market, before Annie Osborn bought it. Like the former Flesher's Fountain next to it, in 1993, its windows were boarded over and its paint was mostly gone. The entire town of Graton was ripe for transformation. (Orrin Thiessen.)

Orrin Thiessen was a local contractor who saw Graton's potential. He bought many of the downtown buildings in 1994 and went to work, using old photographs of Graton as inspiration. He first remodeled the Flesher's Fountain building, which housed the first new business, the Graton Bakery and Café, then tackled the Annie's building, which became the Willow Wood Market and restaurant. New water and sewer lines were installed and new sidewalks. The El Tanapa building was remodeled and became a series of restaurants (Café Dahlia, Kitchen, Cape Fear, Scala's) and is now Green Valley Mortgage and a realty office. (Merrilyn Joyce.)

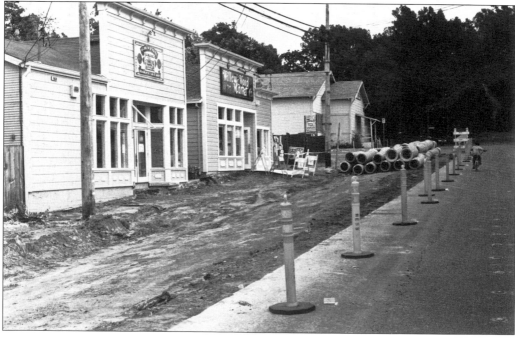

When Orrin Thiessen started to work on the Annie's building, he discovered the walls were full of bees. A huge hive had filled most of one exterior wall with honeycomb. A professional beekeeper came and removed the bees so work could proceed. (Orrin Thiessen.)

Skip's was remodeled and became, briefly, a restaurant called Passionfish. The building was bought by Lulu Spittles and Matthew Greenbaum, the owners of Willow Wood, and after an extensive remodel and expansion opened in 2000 as the successful Underwood Bar and Bistro. (Merrilyn Joyce.)

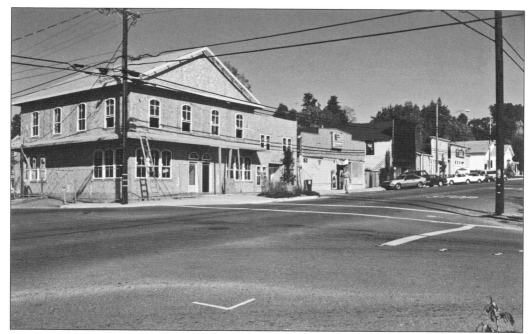

Orrin Thiessen built the new building on the corner to look like the old Graton hotel. Graton was starting to look like its old self. In this picture from 1996, the new building has just had its windows installed and is about to get siding and trim. (Merrilyn Joyce.)

Orrin remodeled the old post office building, but it was purchased by the owners of Patterson's Emporium, the first business to open in it after completion. In 1996, the building next door became Mexico Lindo restaurant, owned by Mario Ramos. Patterson's Emporium is now Mr. Ryder's Antiques, owned by Betty Ann Sutton. (Merrilyn Joyce.)

This 1997 photograph shows a juxtaposition of old and new. The Stop and Shop, soon to become the Graton Market, was kept open during its remodel by having one half of the old Spooner's building remodeled at a time. The store moved into the left half when it was complete, and when the right half was done, it became a bookstore, then the Graton Gallery. (Merrilyn Joyce.)

Graton Day has been held every September since 1993. A parade into Graton kicks off the celebration, leading participants into the closed-off downtown streets to enjoy the kids' area, local food and music, commemorative T-shirts, and fun contests. The day closes with dancing in the street. In 2005, Graton Day paid tribute to the town's 100th birthday. Bob Engel dressed as James Gray and led the parade. A Graton history museum was created in the Graton Community Club, and the community came together to celebrate Graton, both old and new. (Barbara Jeppeson.)

ACROSS AMERICA, PEOPLE ARE DISCOVERING SOMETHING WONDERFUL. THEIR HERITAGE.

Arcadia Publishing is the leading local history publisher in the United States. With more than 5,000 titles in print and hundreds of new titles released every year, Arcadia has extensive specialized experience chronicling the history of communities and celebrating America's hidden stories, bringing to life the people, places, and events from the past. To discover the history of other communities across the nation, please visit:

www.arcadiapublishing.com

Customized search tools allow you to find regional history books about the town where you grew up, the cities where your friends and family live, the town where your parents met, or even that retirement spot you've been dreaming about.